BEDTIMESTORIES

VDO English

Illustrated by:	Jianbo Tong
Written by:	Rynn Song
Copy editing by:	Madeleine Fitzpatrick
Produced by:	Zhou Li Tan Yan
Presented by:	China Daily Hong Kong Limited, VDO English
Edited by:	Betty Wong
Cover designed by:	Maggie Mak Jianbo Tong
Published by:	The Commercial Press (H.K.) Ltd.
	8/F, Eastern Central Plaza, 3 Yiu Hing Road,
	Shau Kei Wan, Hong Kong
Distributed by:	The SUP Publishing Logistics (H.K.) Ltd.
	16/F Tsuen Wan Industrial Centre, 220–248 Texaco
	Road, Tsuen Wan,
	NT, Hong Kong
Printed by:	Wing King Tong Printing Ltd.
	Leader Industrial Centre Phase 1–2,
	3/F, Block 1, 188–202 Texaco Road, Tsuen Wan,
	NT, Hong Kong

© 2022 The Commercial Press (H.K.) Ltd.

First Edition, First Printing, July 2022

ISBN 978 96207 0605 9

Printed in China

Contents

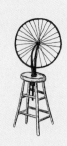

Leon Batista Alberti

1

scan to watch video

Story of
the Star Prince

I want to tell you a story
about the Star Prince.

One night, long ago, the Star Prince looked up at the starry sky. He was already 47 years old.

Suddenly,
a shooting star flashed by,
and he thought of
his childhood.

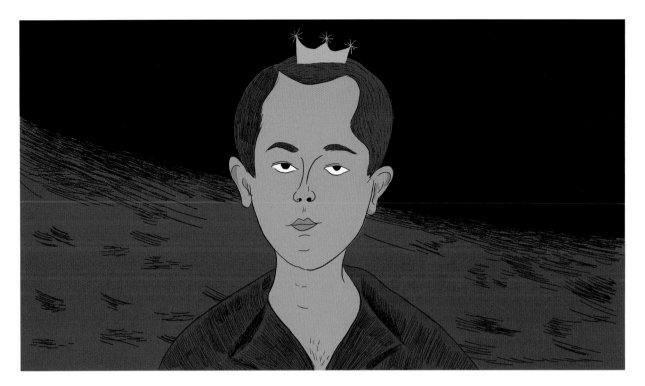

He had been looking at the stars since he was a child, holding a paintbrush in his hand.

He had been painting for
decades. What a difficult
life it had been!

As a child, he was sluggish.

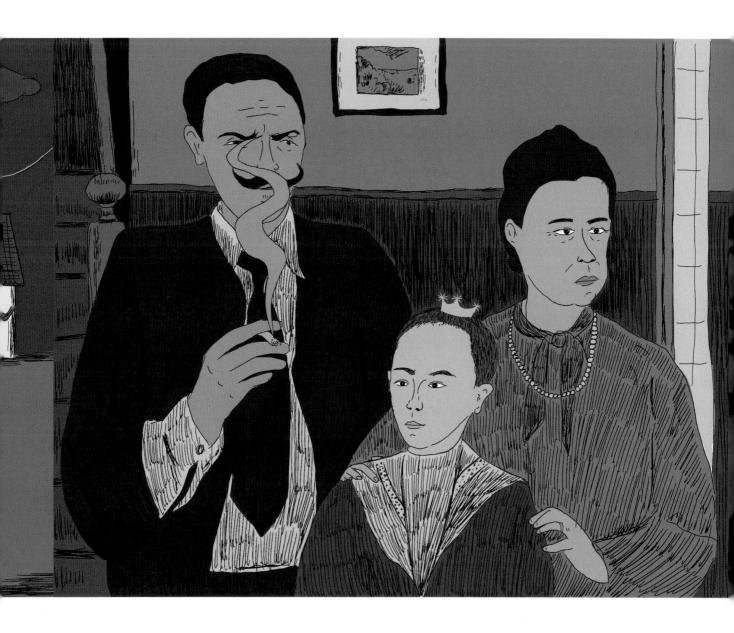

His parents thought he wouldn't amount to anything, and his teachers found him stupid and clumsy.

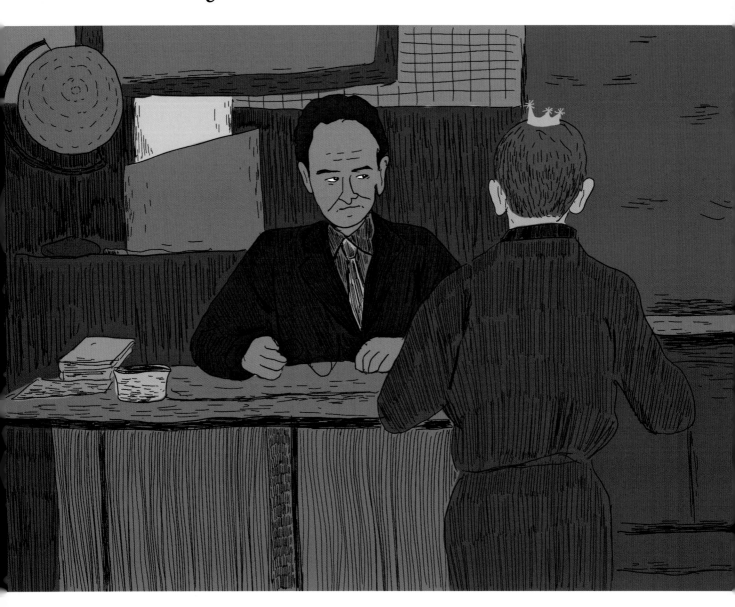

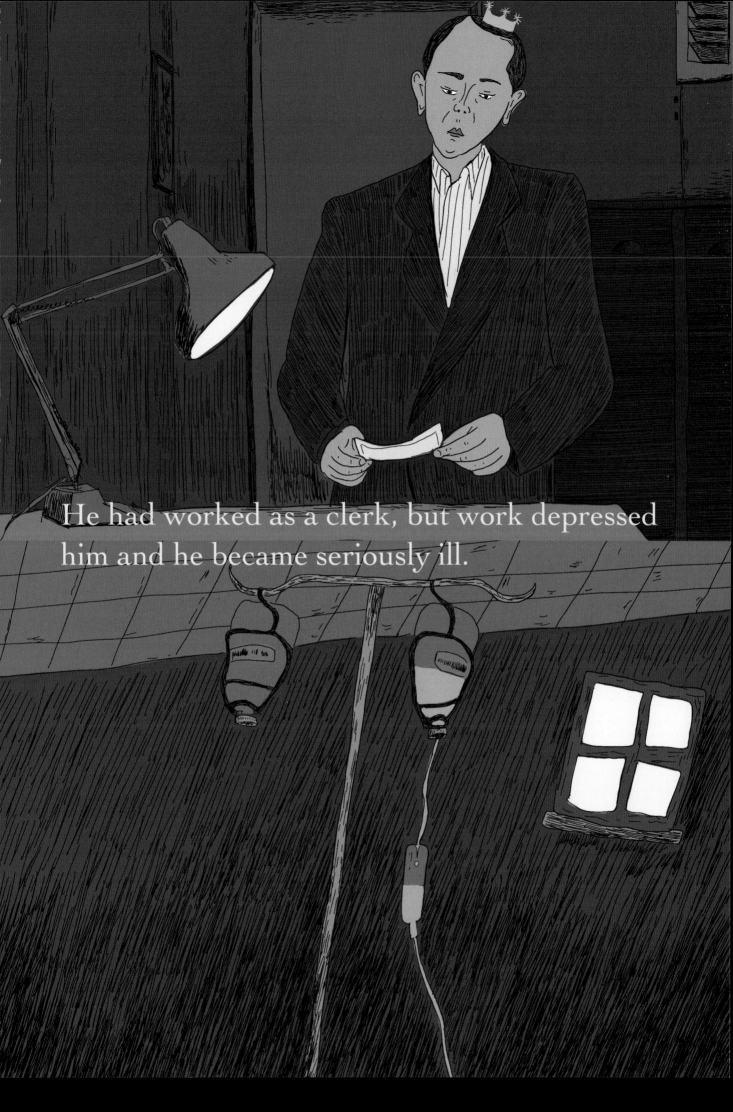

He had worked as a clerk, but work depressed him and he became seriously ill.

In order to pursue his dream of painting, he went to the artistic capital, alone.

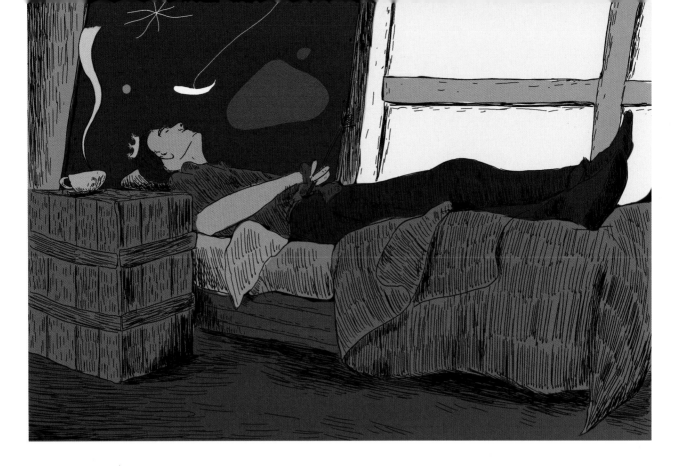

How many times he had gone hungry! Nobody was interested in his paintings.

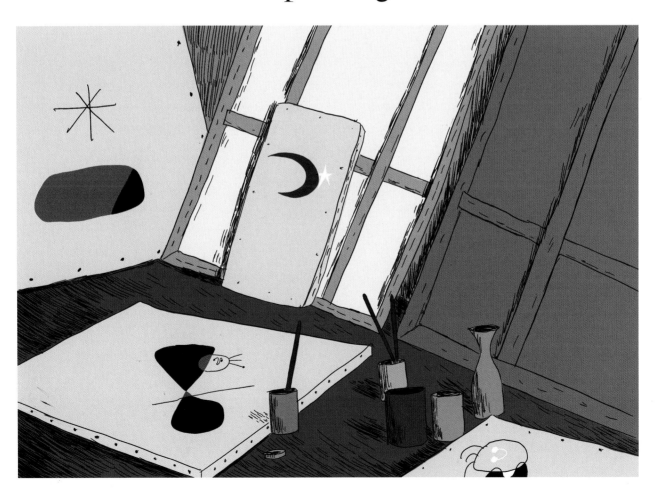

Now, he couldn't even return to his hometown, due to a ceaseless war.

He had nothing except the
paintbrush in his hand.

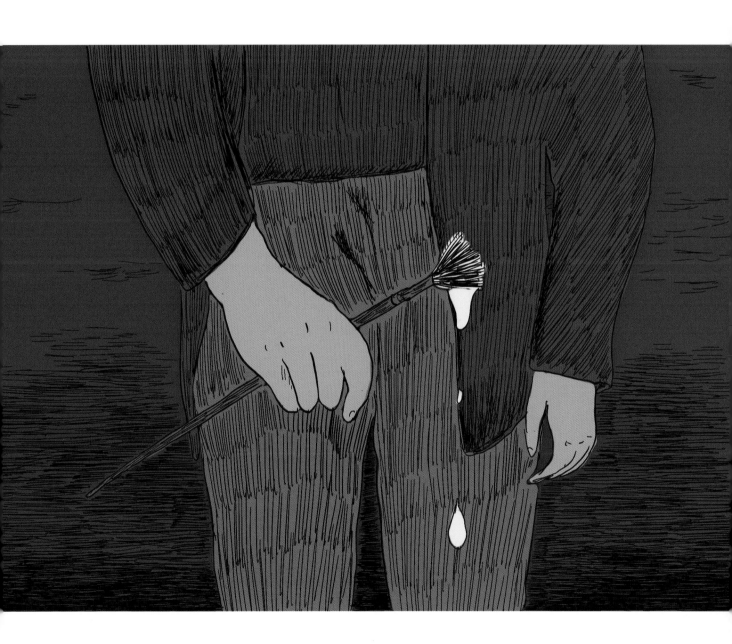

It was at this moment that
he decided to
paint like a child
forever.

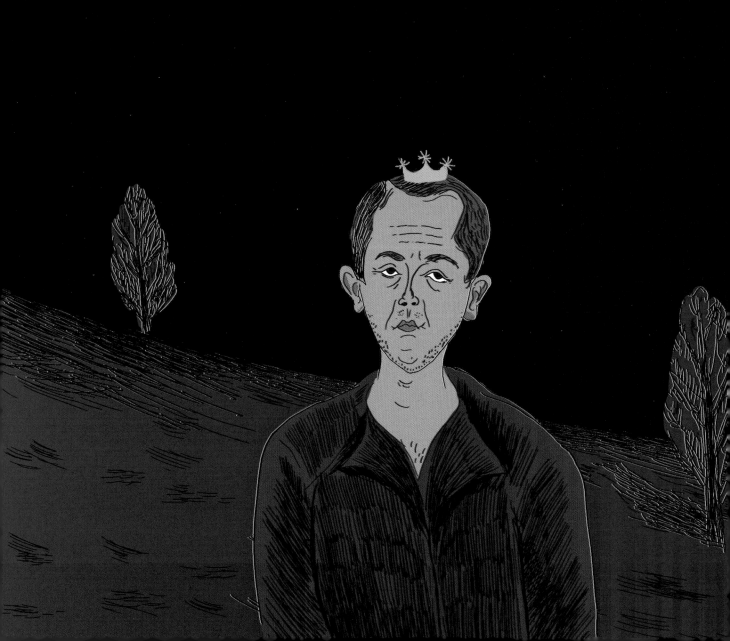

He wanted to paint
a universe of his own.
He wanted to paint
birds, flames, stars, moons,
and anything that symbolized
eternity.

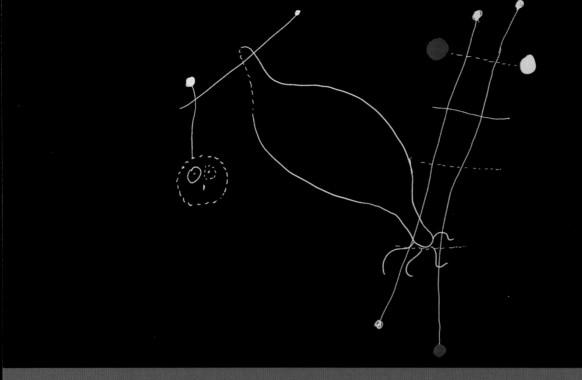

PERSON THROWING A STONE AT A BIRD, 1926

Why am I telling
you this story?

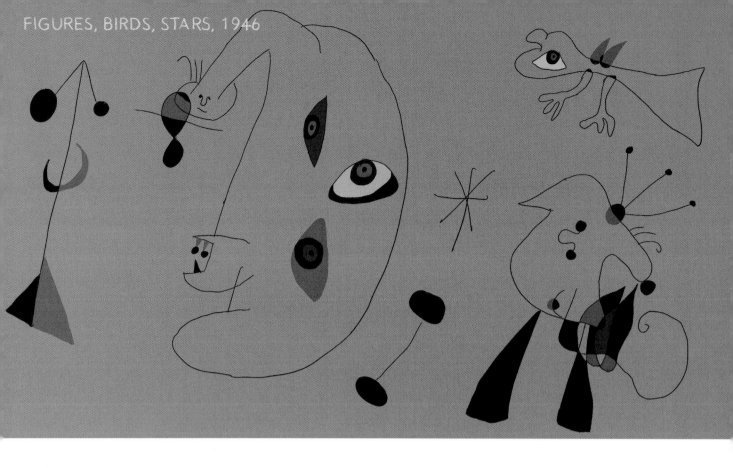

FIGURES, BIRDS, STARS, 1946

The Star Prince taught me one thing:

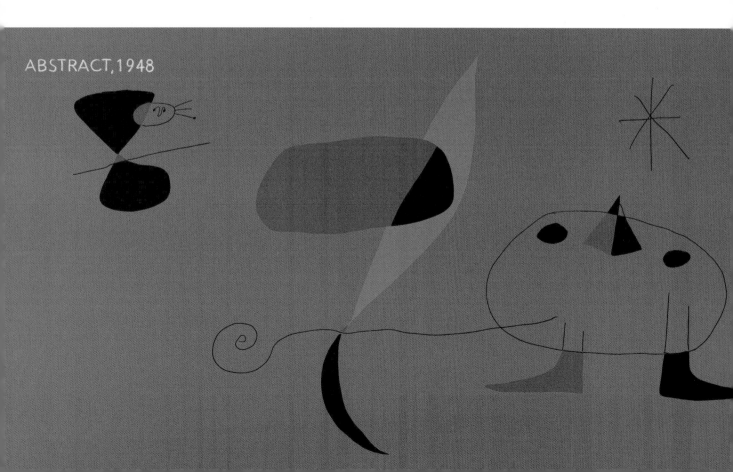

ABSTRACT, 1948

When you grow up, you will
find that this world is not always
beautiful.

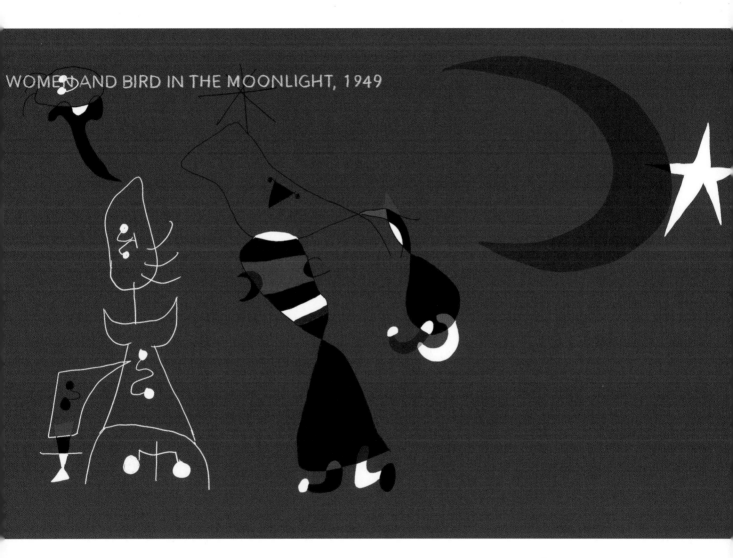

WOMEN AND BIRD IN THE MOONLIGHT, 1949

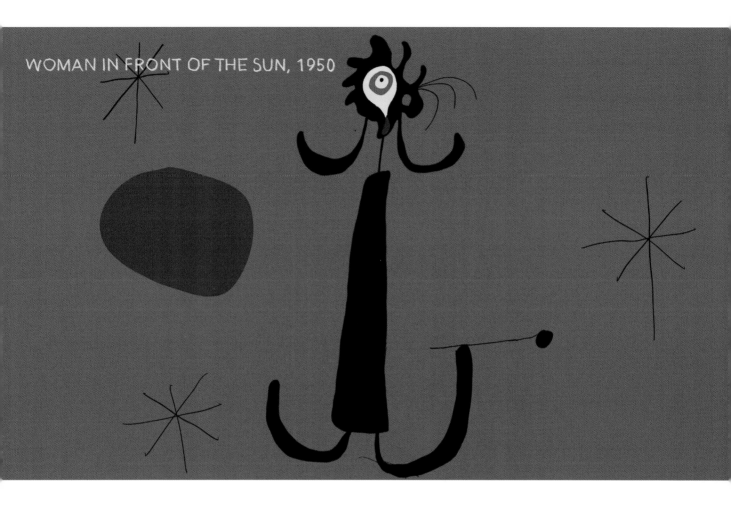

WOMAN IN FRONT OF THE SUN, 1950

Seeing the world through a child's eyes can help people through the toughest times.

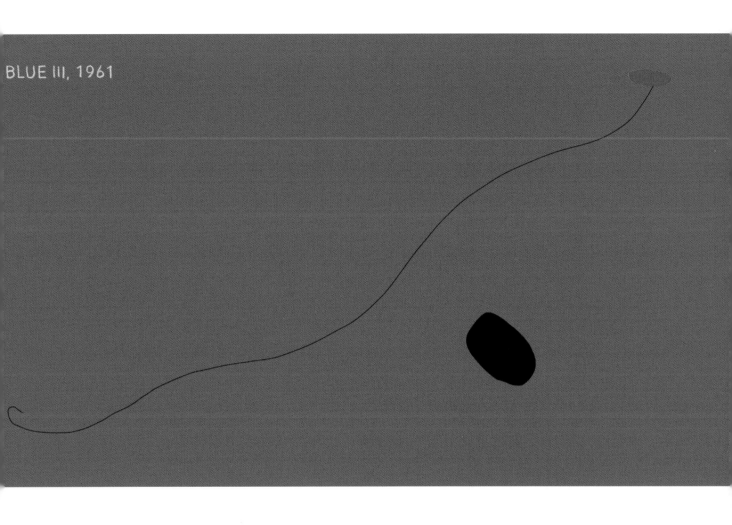

BLUE III, 1961

Unfortunately, most adults don't manage to reach that state.

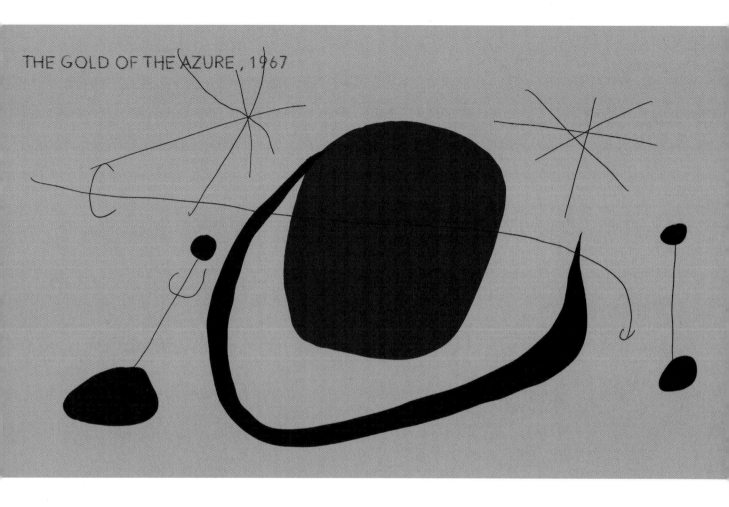

THE GOLD OF THE AZURE, 1967

It takes a long time to become young again.

But the Star Prince succeeded. He drew many paintings, and everyone knew his name.

Even when he became a grandfather, people still called him the Star Prince.

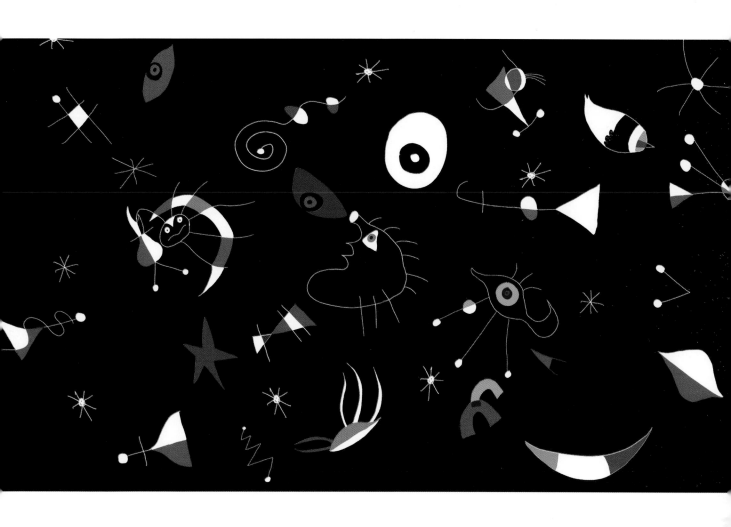

Why did the Star Prince
paint like a child?
Because seeing the world through
the eyes of a child appealed to him.

"I ALWAYS HAVE MY FEET
ON THE GROUND,
AND MY EYES ON THE STARS."

—— Joan Miró (1893-1983)

What does that world look like?
I think you know better than me.

Good night.

2

scan to watch video

The oldest paintings

Cueva de los Caballos, Spain

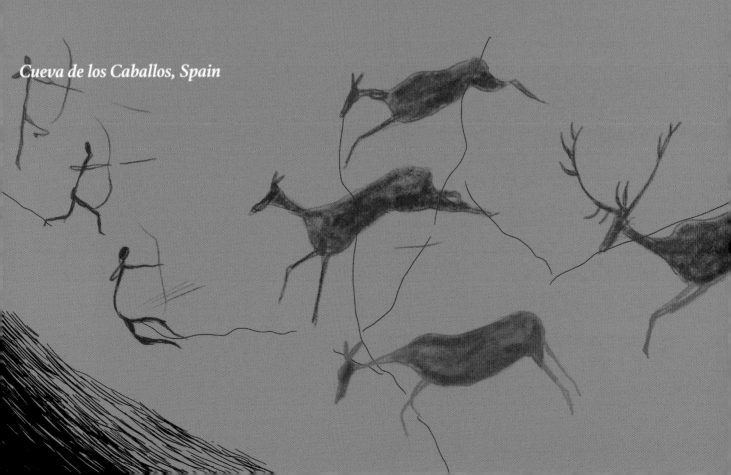

In 1879, Spanish landowner Marcelino Sanz de Sautuola was searching for prehistoric artifacts on the floor of the Cave of Altamira, on his family's property in northern Spain.

31

Suddenly, his eight-year-old daughter
Maria, called out, "Look, Papa – oxen!"
Marcelino looked up at the cave's
ceiling and saw paintings of bison – big
enough to be almost life-sized – that
appeared to be tumbling across the sky.
Although 14,000 years had passed, the
delicate paintings were still vivid.

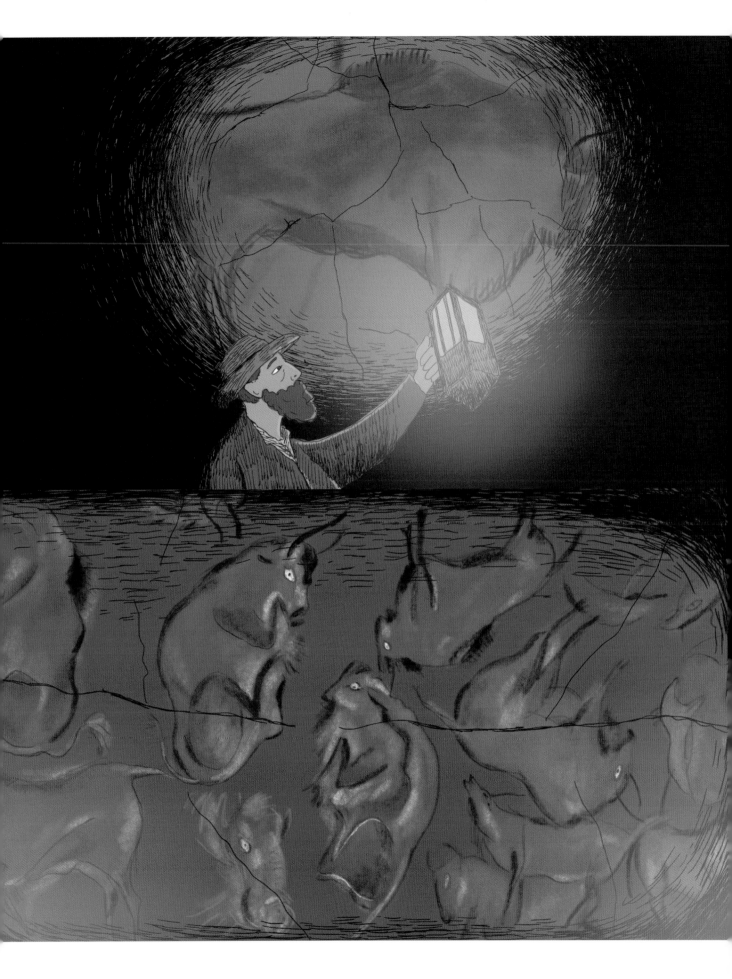

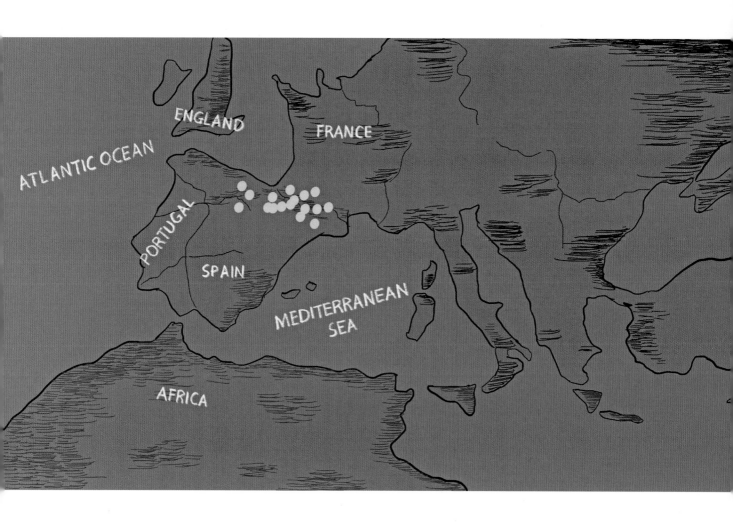

Since then, ancient cave paintings
have entered the popular imagination.
Thousands of similar paintings have
been discovered in more than 200 caves
scattered across southwestern France
and northeastern Spain, on either side of
the Pyrenees mountain range.

34

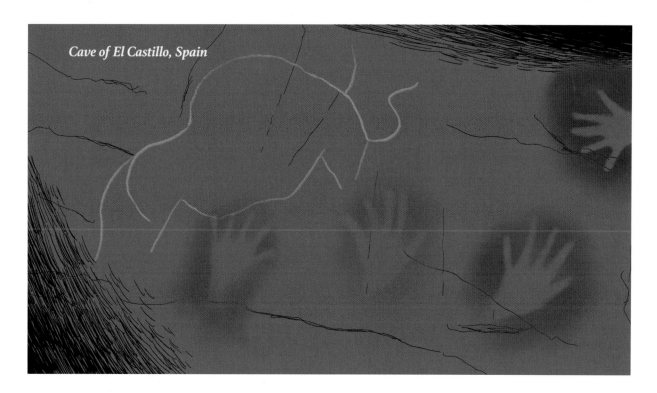

Cave of El Castillo, Spain

Have a close look at some of them… They look pretty simple, right? Yet, they're as clear a depiction of the animals represented as any painter could produce today.

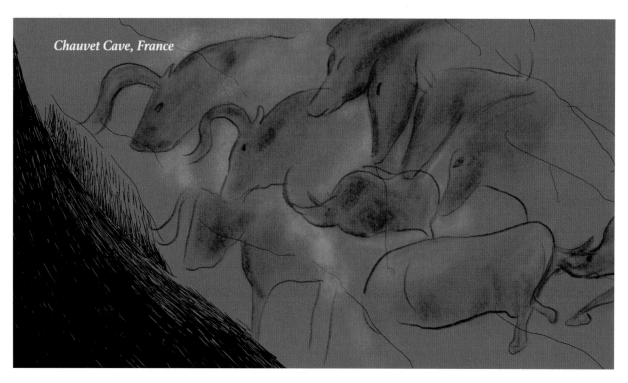

Chauvet Cave, France

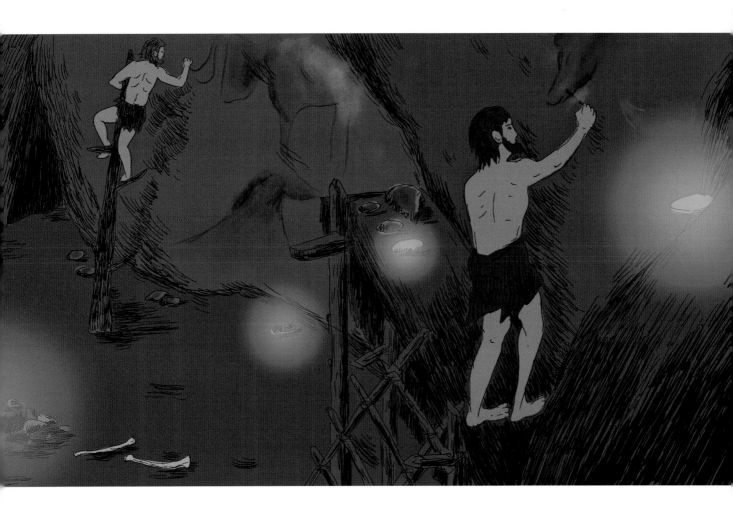

Imagine early humans standing on wooden scaffolding, painting with pigments – red made from iron oxide, black from manganese.

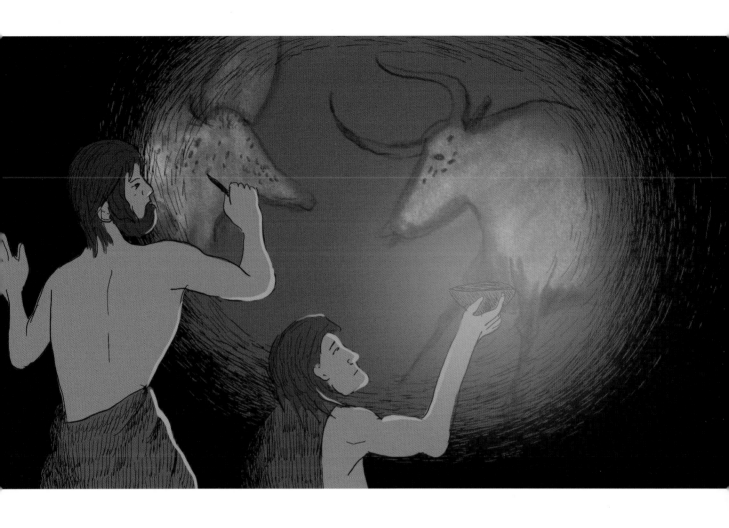

Prehistoric painters faced a scarcity of pigments, and created art through various methods including spraying, block printing, carving and charcoal drawing.

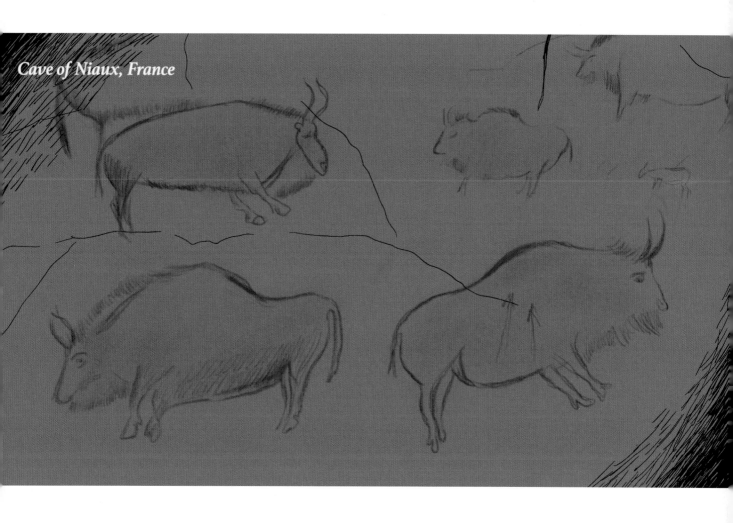

Cave of Niaux, France

Why do you think early humans painted animals on cave walls? Just for decoration?

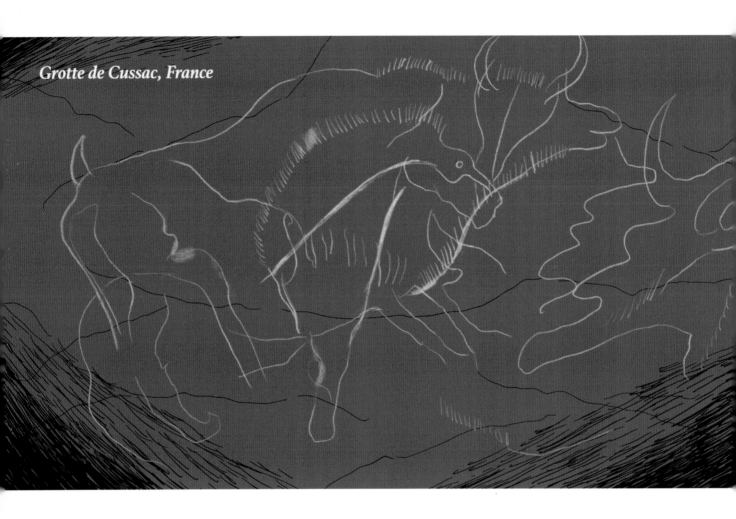

Grotte de Cussac, France

That seems unlikely, considering
how dark the caves were.

40

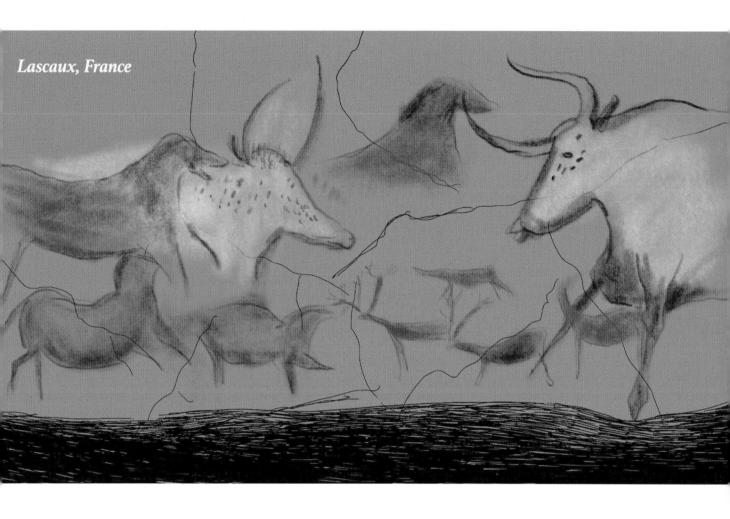

Lascaux, France

We think they painted the animals to provide information, as a kind of hunting reference.

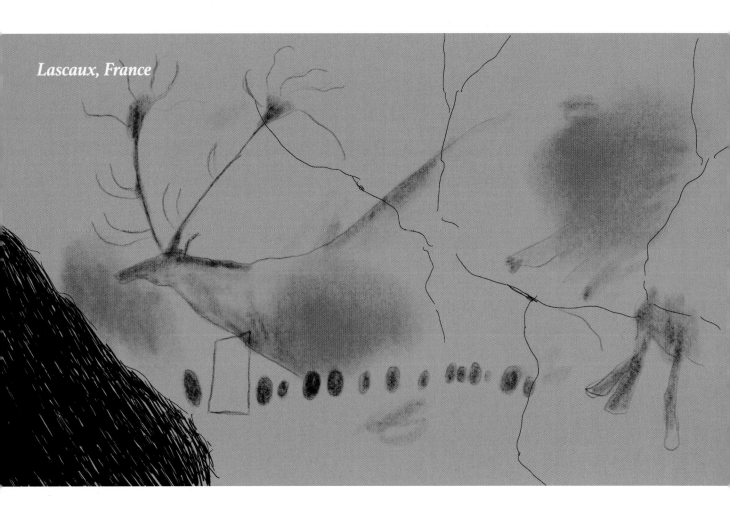

At the same time, the carvings may
have been part of a ritual – to pray
for a successful hunt.

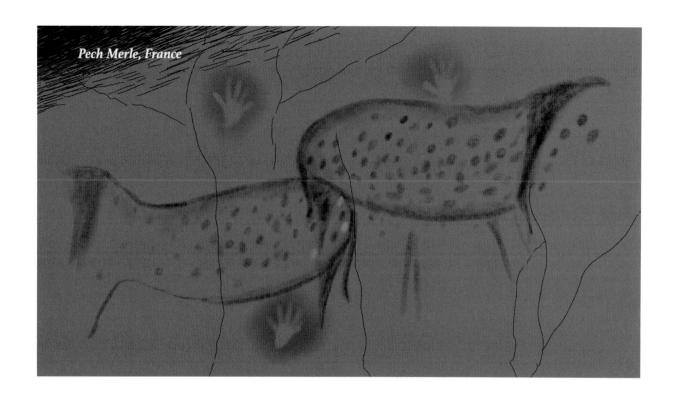

Pech Merle, France

We can't be sure of course, and the full reasons will forever remain a mystery.

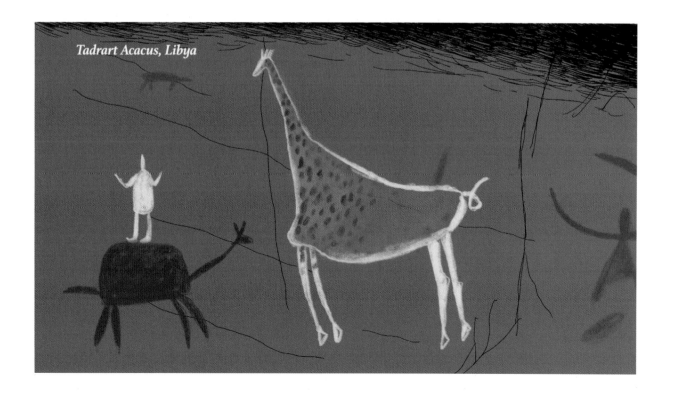

Tadrart Acacus, Libya

43

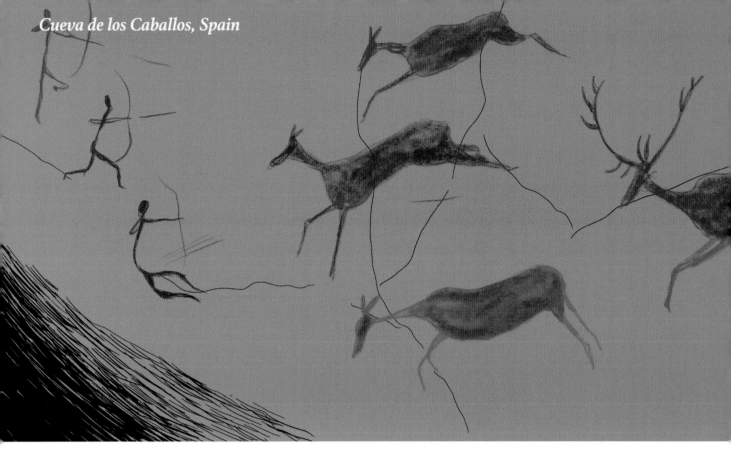

Cueva de los Caballos, Spain

But take a look at some of the paintings.

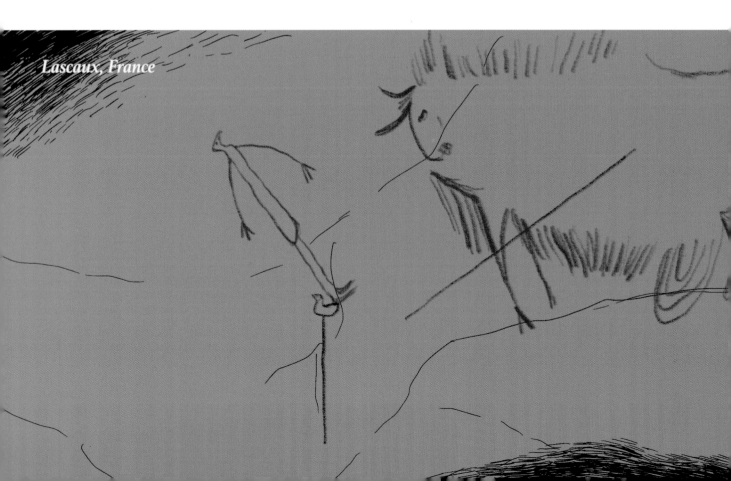

Lascaux, France

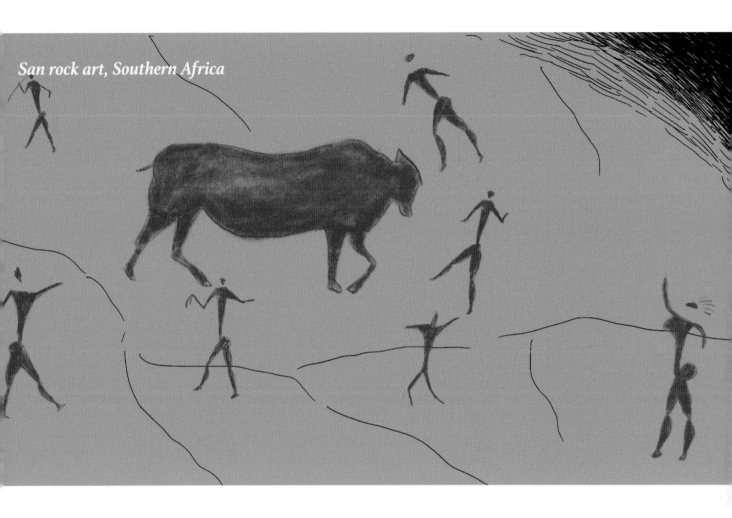

San rock art, Southern Africa

Prehistoric people told stories with pictures, just like we do today. At the time, writing had not been invented yet.

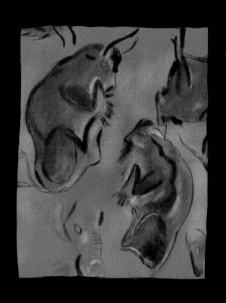

What inspiring artworks.
Do you like them?

Good night.

3

scan to watch video

Fill your paper with the breathings of your heart

Here's something you should be familiar with – we write on it, draw on it, and read books made of it.

This material was also key in the development of modern visual art. So tonight, let's talk about paper.

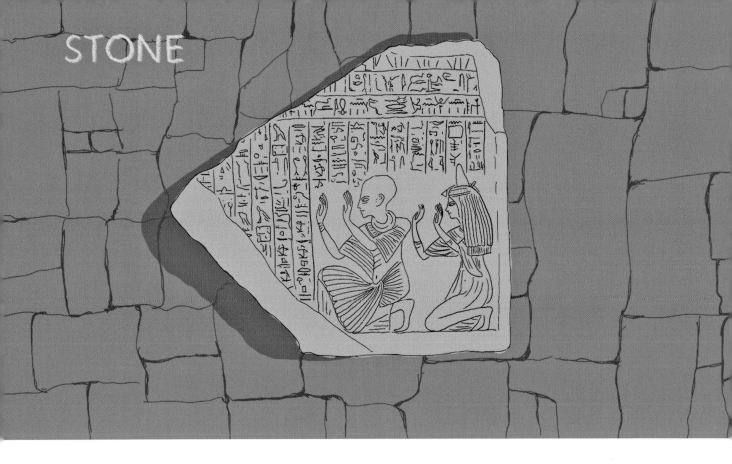

STONE

Before we had paper, people would write on tortoise shells, bamboo, and later textiles and scrolls.

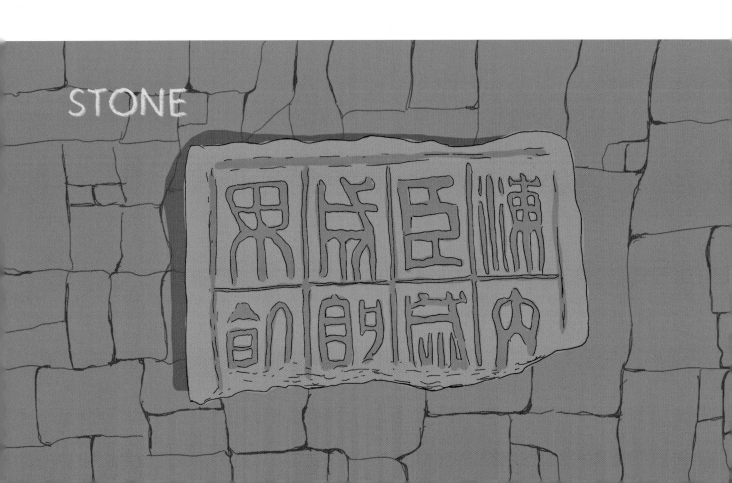

STONE

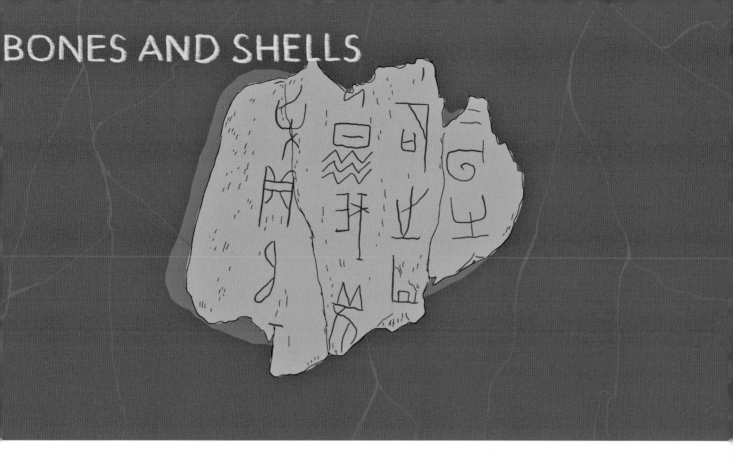

These materials were good enough for recording simple things.

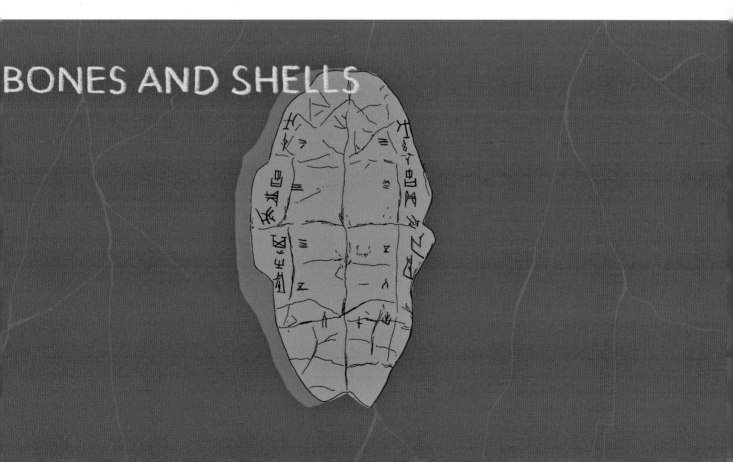

BRONZEWARE

BRONZEWARE

BAMBOO

BAMBOO

You had to be careful not to write too much though – as otherwise your "notebook" would end up very heavy and hard to carry.

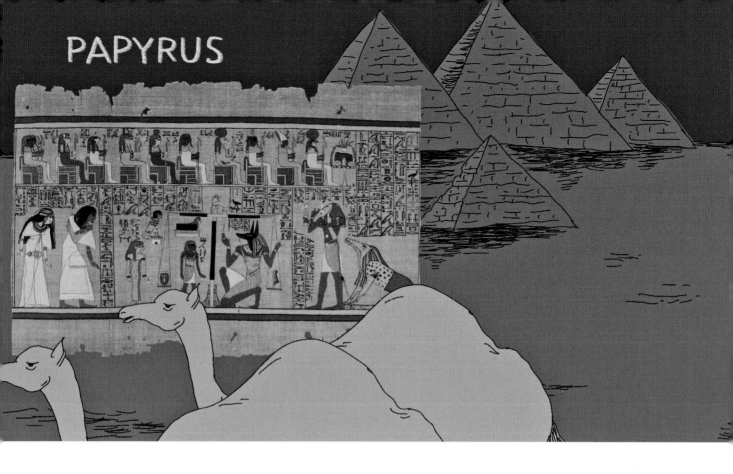

PAPYRUS

There was a thick kind of paper, called papyrus, in ancient times, but this was fragile; while another alternative, parchment – made from animal skins – was expensive.

SILK

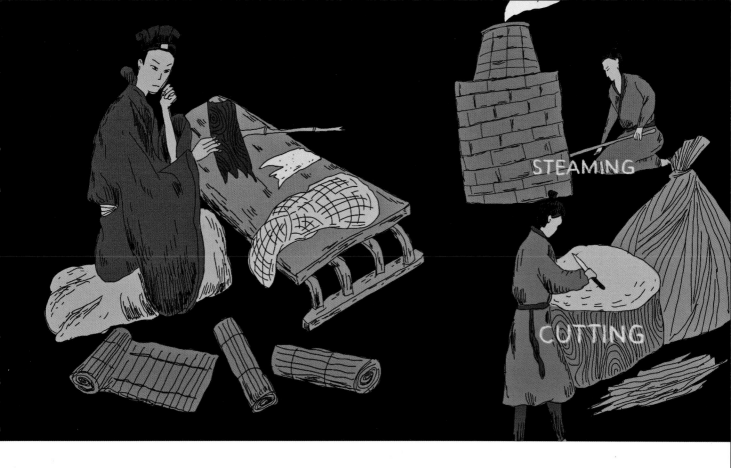

Things began to improve after Cai Lun, a court official during China's Han Dynasty, applied himself to studying the manufacturing techniques of the day.

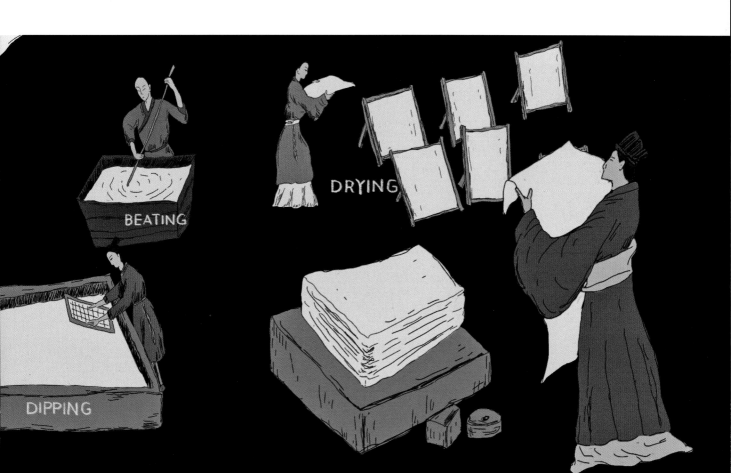

Cai went on to develop a new kind of paper: one lighter, cheaper and higher in quality. Paper's popularity as a medium quickly exploded.

People can write and paint on good-quality paper that will stand the test of time. Look at this ancient Chinese painting: its details are crisp and clear, even after hundreds of years. Since Cai Lun's invention nearly 2,000 years ago, paper hasn't changed all that much.

ZHAO MENGFU (1254-1322)
BAMBOO, ROCK AND WITHERED TREE

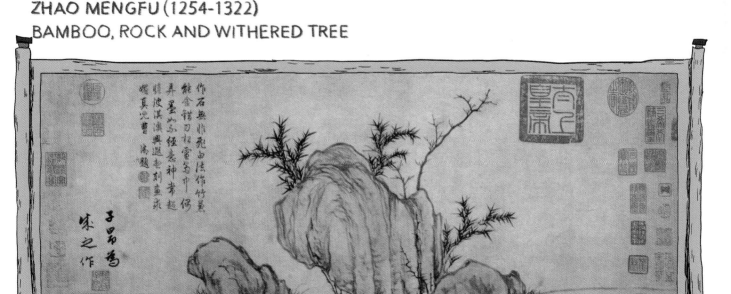

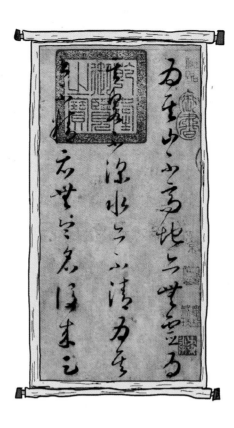

Paper is the medium for various forms of art.

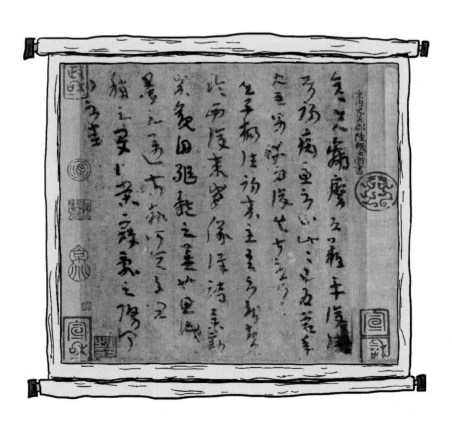

Look at this picture – it's the first photograph ever taken, some time in 1826 or '27.

How about these collages, created by Pablo Picasso and Georges Braque in 1912.

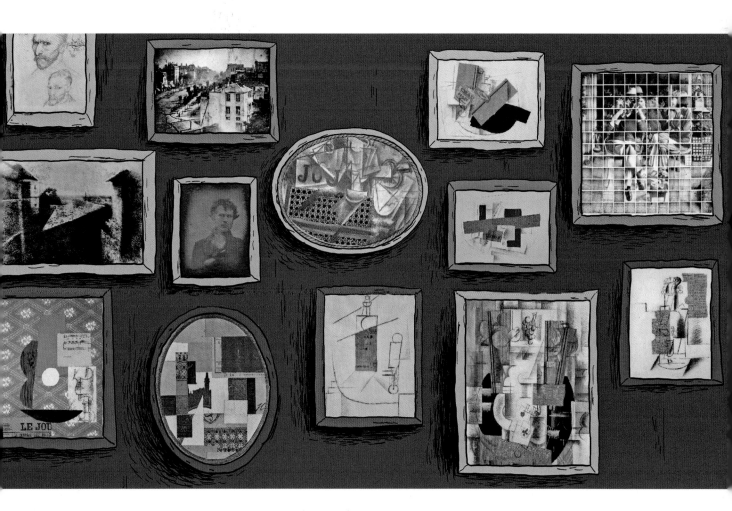

To make their innovative collages, the artists glued assorted materials to colored paper, newspaper or board.

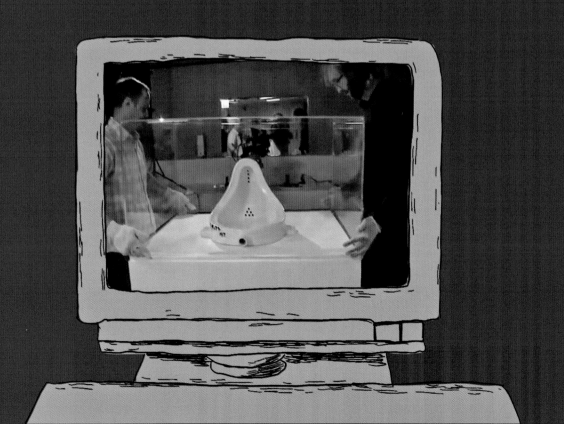

Contemporary artists have also found innovative ways to use the medium, from ripping it to splashing molten wax or other liquids on paper.

ALL ART IS BUT DIRTYING
THE PAPER DELICATELY.

—— JOHN RUSKIN

Want to know more about art? Stay
tuned! Good night.

4

scan to watch video

Beyond
the horizon

15,FLORENCE

Let's draw a picture of a house – the simplest way of doing it is like this.

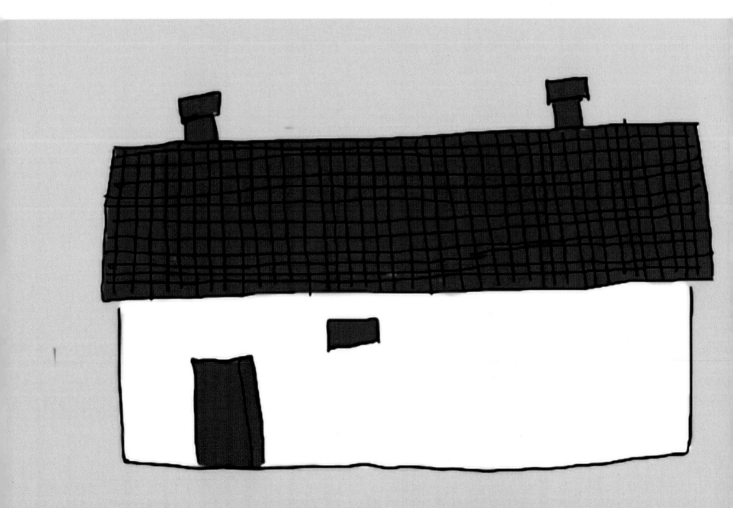

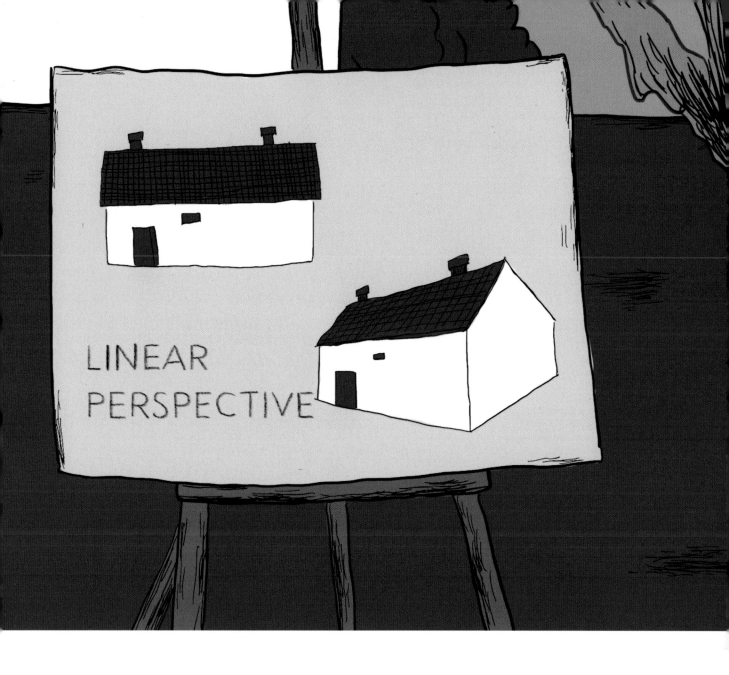

What if we want it to be more real and stereoscopic? That's where we need to use linear perspective, like this.

After seeing this example, you may have a basic idea of what linear perspective is. It's a system for creating the illusion of depth on a flat surface.

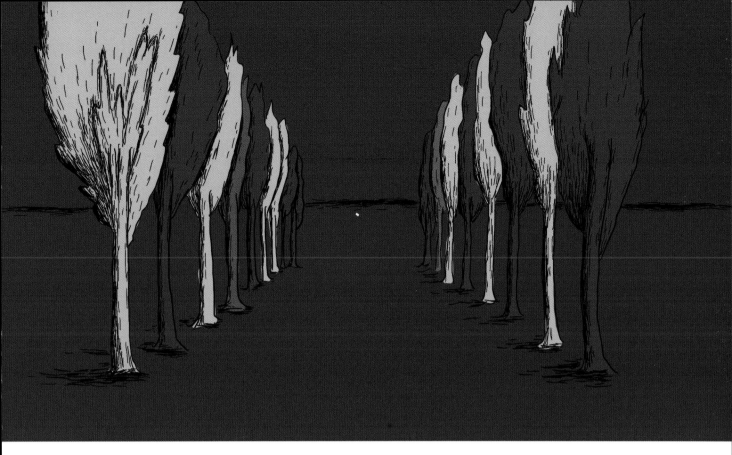

The three components essential to linear perspective are: orthogonals, aka parallel lines; the horizon line; and the vanishing point.

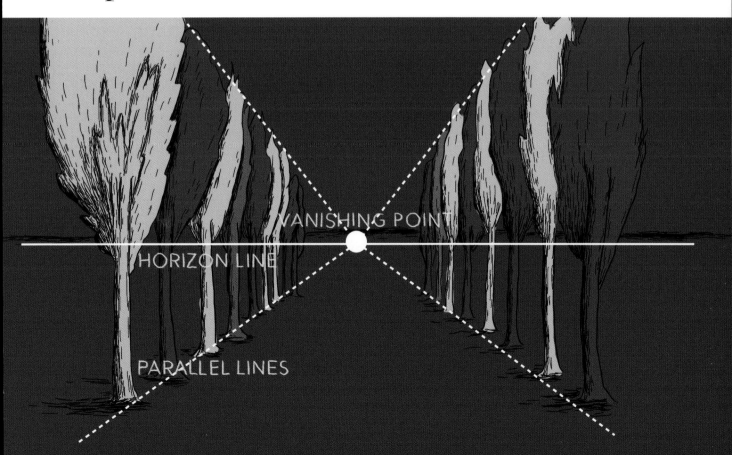

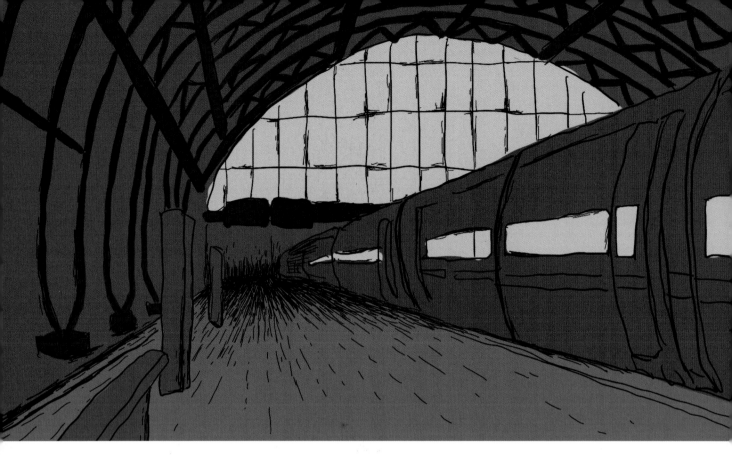

To make them appear farther from the viewer, objects in the composition are rendered increasingly small as they near the vanishing point.

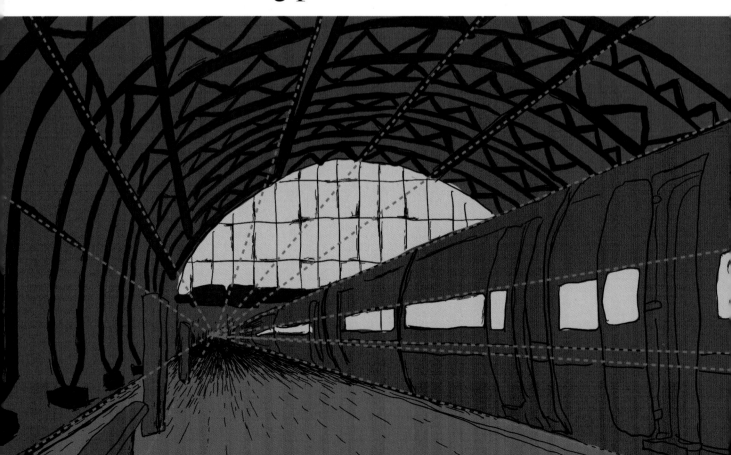

All the parallel lines in a painting
or drawing converge in a single
vanishing point on the composition's
horizon line.

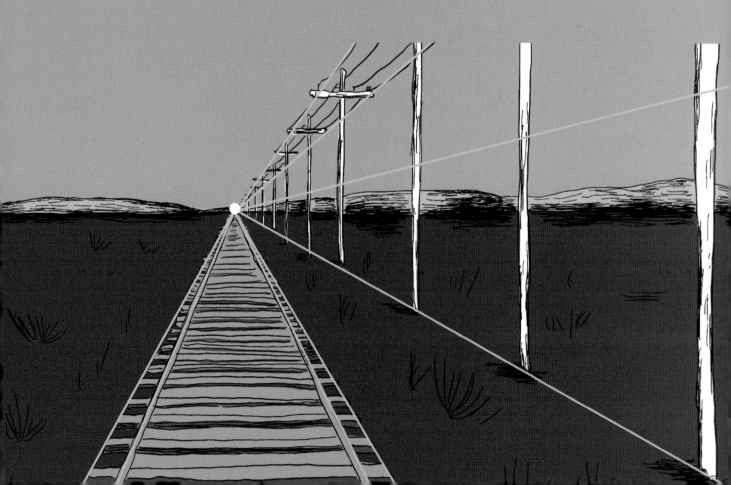

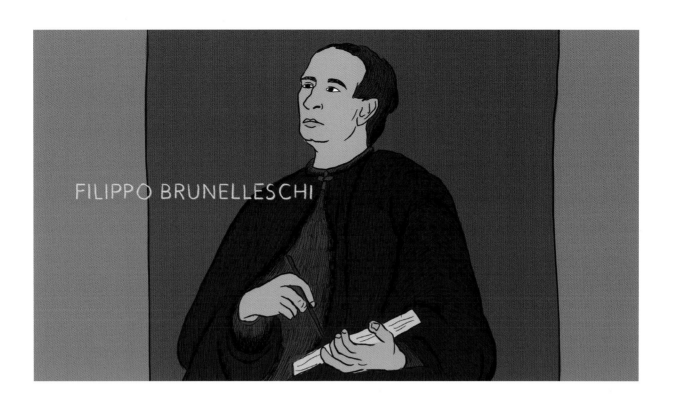

FILIPPO BRUNELLESCHI

Linear perspective is believed to have been devised in around 1415 by the Italian Renaissance architect Filippo Brunelleschi. The technique was documented in 1435 by the architect and writer Leon Battista Alberti in his book *Della Pittura* – or *On Painting*, in English.

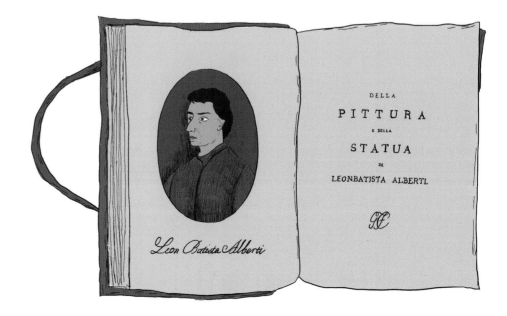

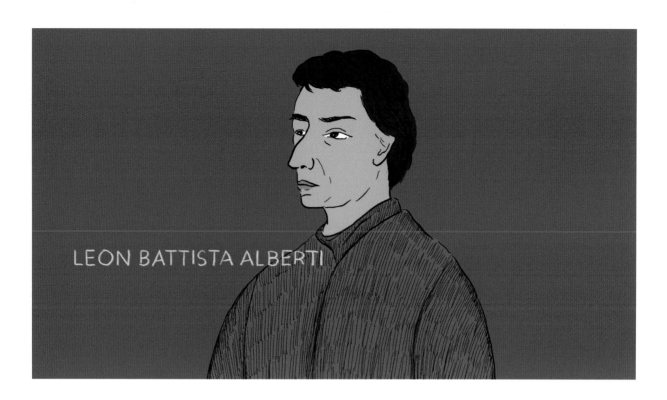

This is a figure from *Della Pittura* showing the vanishing point in a linear perspective drawing. Explains the author, "The pyramid is a figure from whose base straight lines are drawn upward, terminating in a single point."

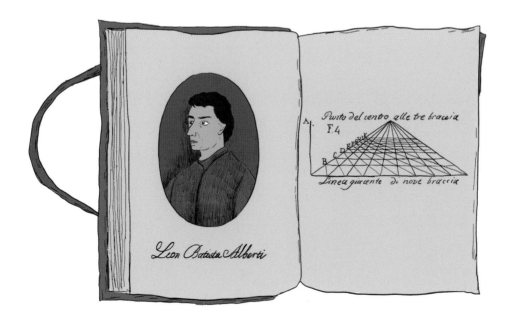

MASACCIO

A student of Brunelleschi, the early Italian Renaissance painter Masaccio, was the first painter to apply linear perspective to his work – which he did in this fresco, called *The Holy Trinity*.

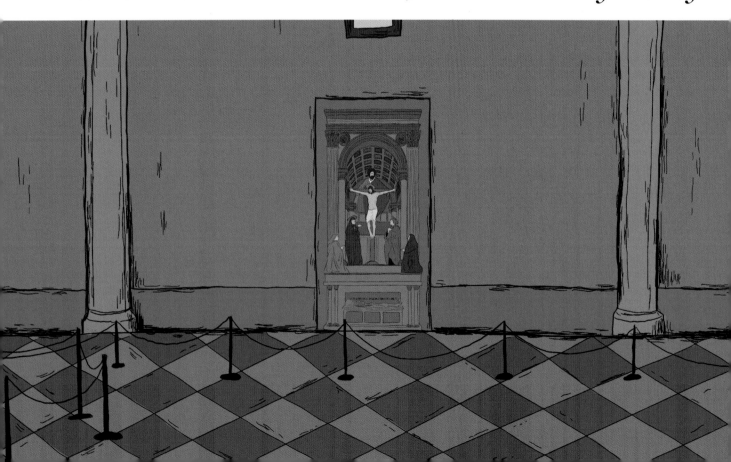

Masaccio painted from a low viewpoint, as though we are looking up at Christ. We see the orthogonals in the ceiling; if we traced them, we would see that the vanishing point is on the ledge where the kneeling figures are situated.

THE HOLY TRINITY, 1426-1428

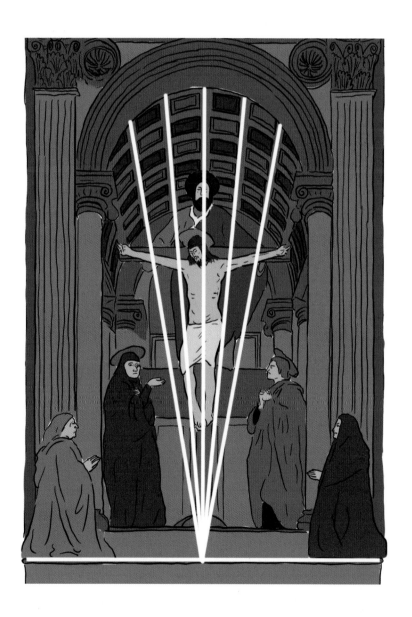

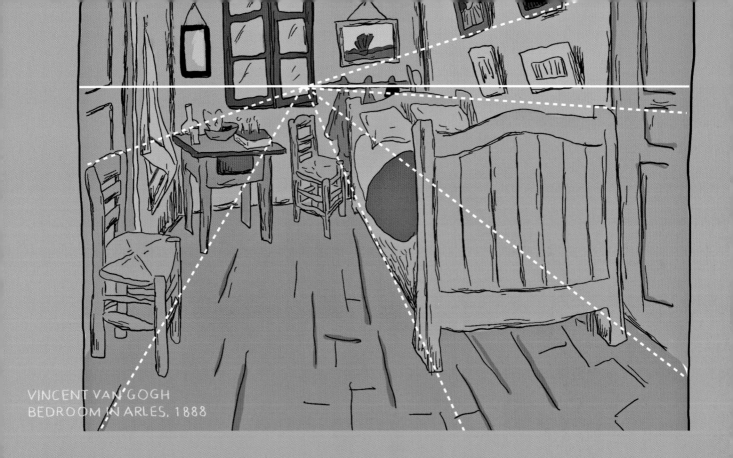

VINCENT VAN GOGH
BEDROOM IN ARLES, 1888

Linear perspective has been a core component of art theory since the 17th century. What is its significance in visual art?

GIORGIO DE CHIRICO
MYSTERY AND MELANCHOLY OF
A STREET, 1914

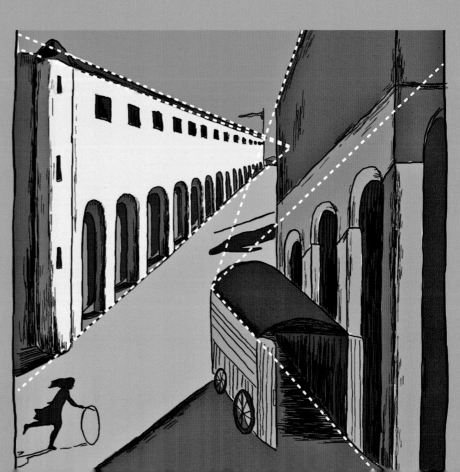

LEONARDO DA VINCI
THE LAST SUPPER, 1495-1498

Linear perspective enables artists to create
realistic representations of our 3D world.

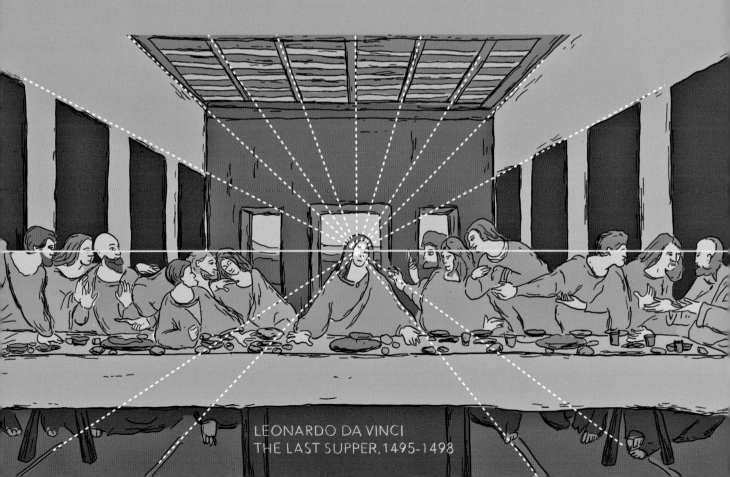

LEONARDO DA VINCI
THE LAST SUPPER, 1495-1498

MEINDERT HOBBEMA
THE ROAD TO MIDDELHARNIS, 1689

I know it's a lot to digest – take your time, and maybe try to draw a picture using linear perspective.
Goodnight.

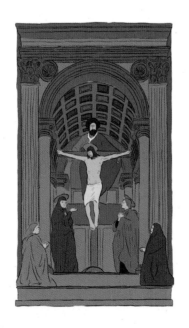

"PERSPECTIVE IS TO PAINTING
WHAT THE BRIDLE IS TO THE
HORSE, THE RUDDER TO A SHIP."

— LEONARDO DA VINCI

82

5

scan to watch video

Say cheese!

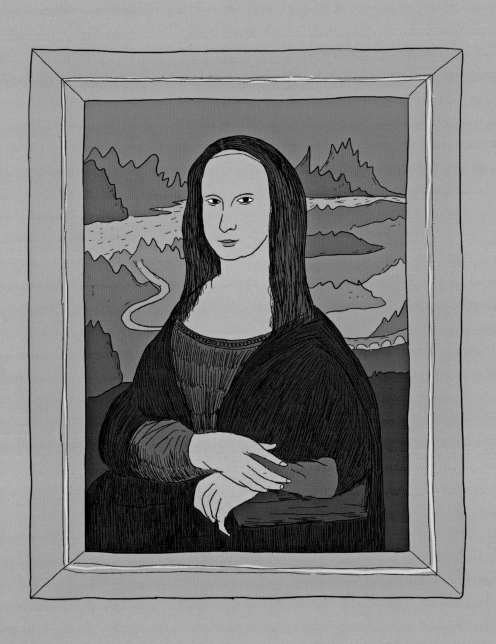

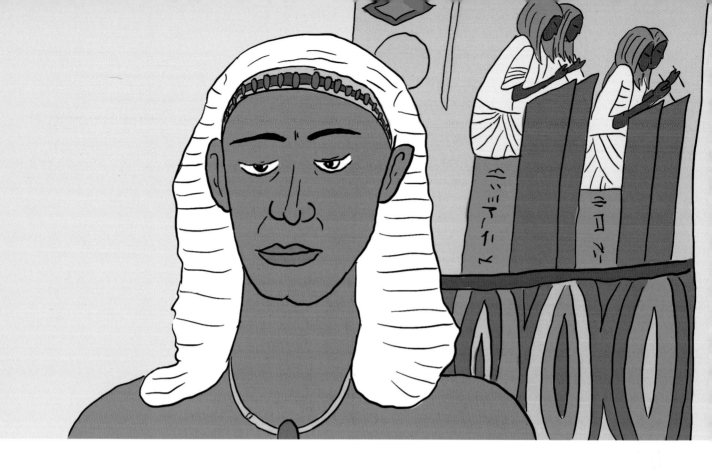

Bak was bored. As Pharaoh's chief
royal sculptor, he had no need to
worry about his livelihood.

The sun burned down on the city of Akhet-Aten.

Bak thought about his wife Taheri,
and how much he loved her.

He considered how to express his affection, and finally decided to make a *stela* of himself and Taheri, to commemorate their eternal devotion for one another.

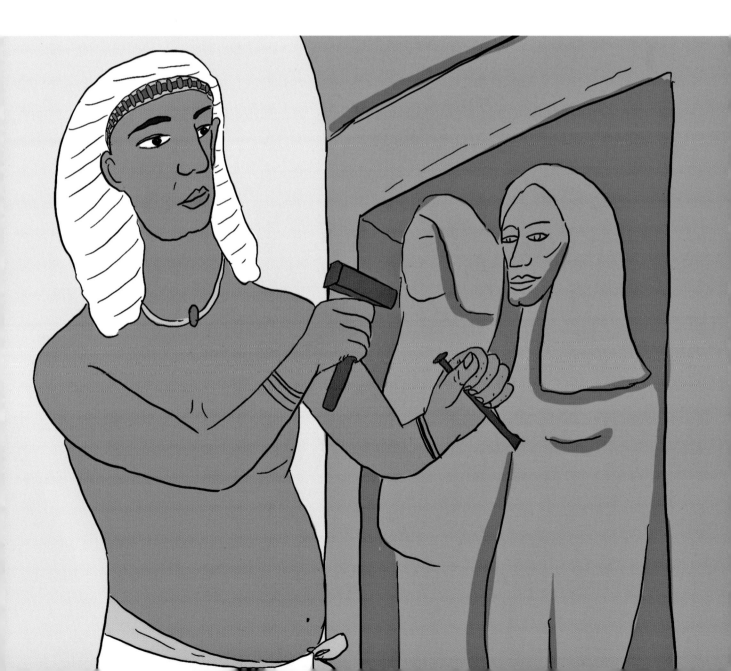

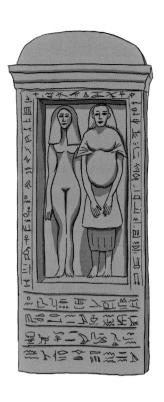

Nearly 3,400 years later, the *stela* lives on in the Egyptian Museum of Berlin. It is one of the world's earliest surviving self-portraits.

Ada is wandering around the
museum. On seeing the *stela*, she is
deeply moved.

She takes a selfie, posts it on Instagram and writes: "I just read a lovely story."

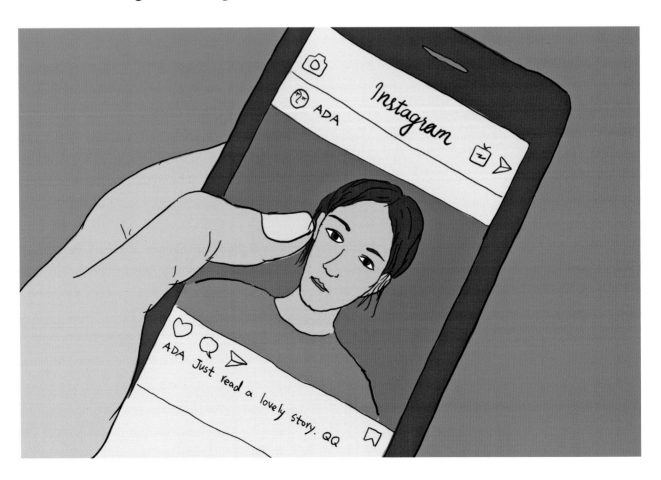

From Bak to Ada, human beings like to create self-portraits as well as portraits of other people.

One of the most famous portraits
in history is the *Mona Lisa*, by
Leonardo da Vinci.

At the time, only wealthy people could have their portraits painted; later, it became more affordable for middle-class families to commission portraits.

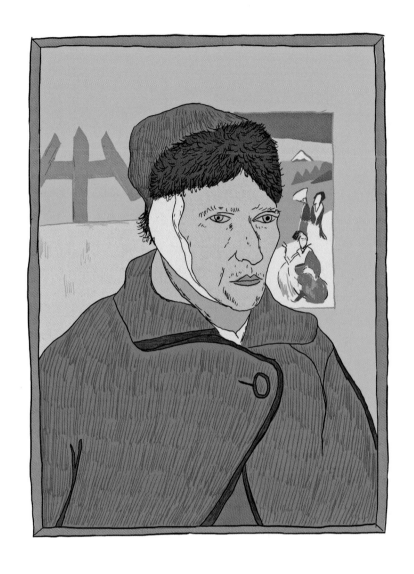

You may be familiar with this Van Gogh self-portrait, done after the artist mutilated his left earlobe.

Van Gogh loved self-portraits – he painted more than 35 over the course of a decade. From these portraits, we know that the artist had red hair, green eyes and an angular face.

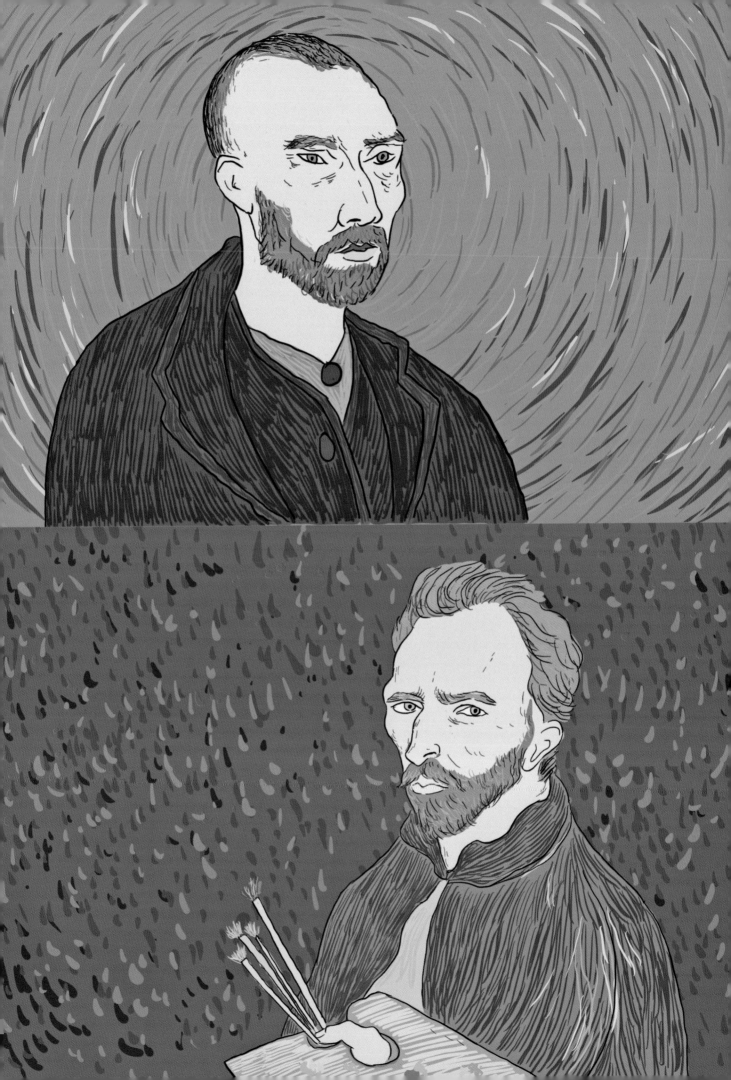

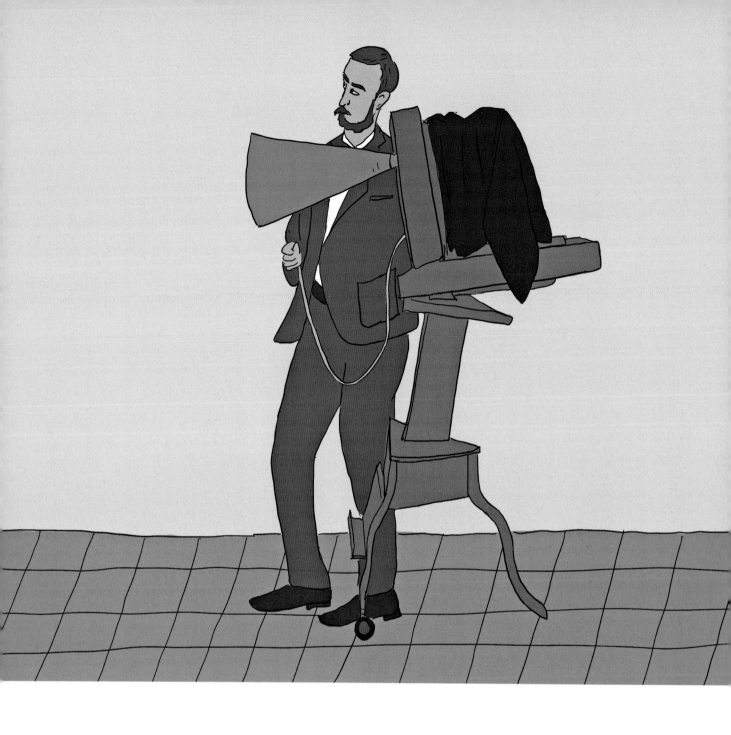

Then, a new technology changed the game: photography.

In 1839, a man named Robert Cornelius took the world's first selfie.

On the back of the photograph, he wrote, "The first light picture ever taken".

The first light picture ever taken!

Nearly 200 years later, many of us take selfies on a regular basis. It's a way to reinforce our sense of self as well as record ourselves at various life stages.

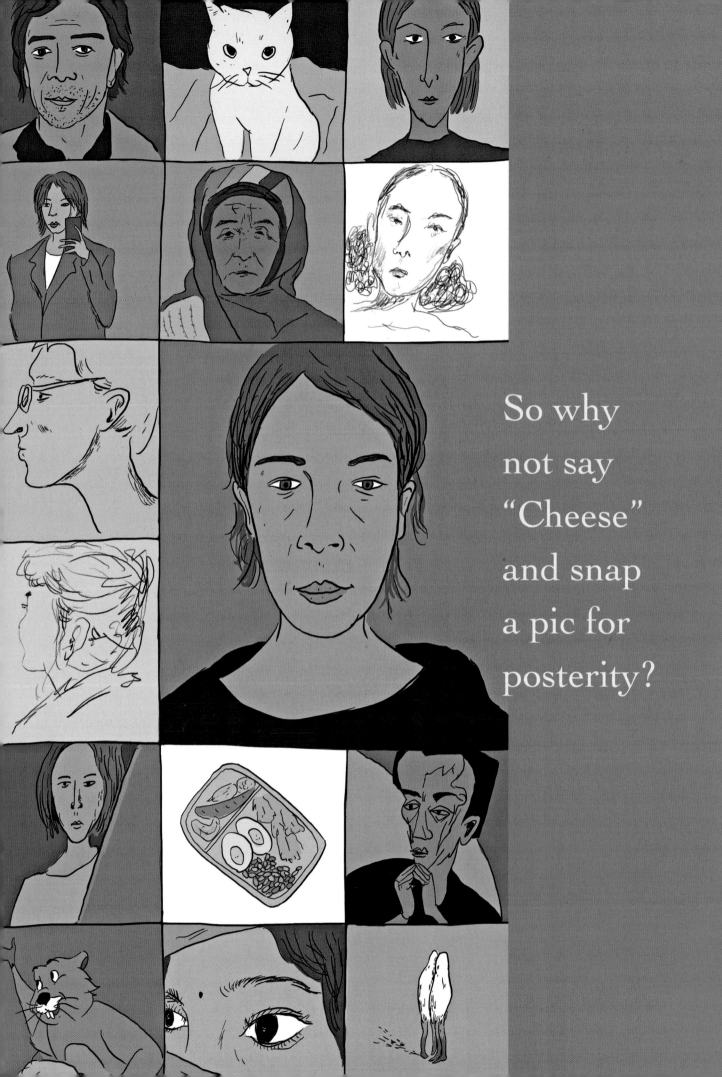

So why
not say
"Cheese"
and snap
a pic for
posterity?

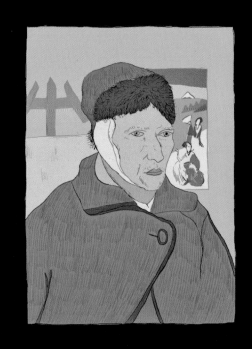

"PEOPLE SAY - AND I'M QUITE WILLING TO BELIEVE IT - THAT IT'S DIFFICULT TO KNOW ONESELF - BUT IT'S NOT EASY TO PAINT ONESELF EITHER."

— VINCENT VAN GOGH

Good night.

6

scan to watch video

I think,
therefore I am

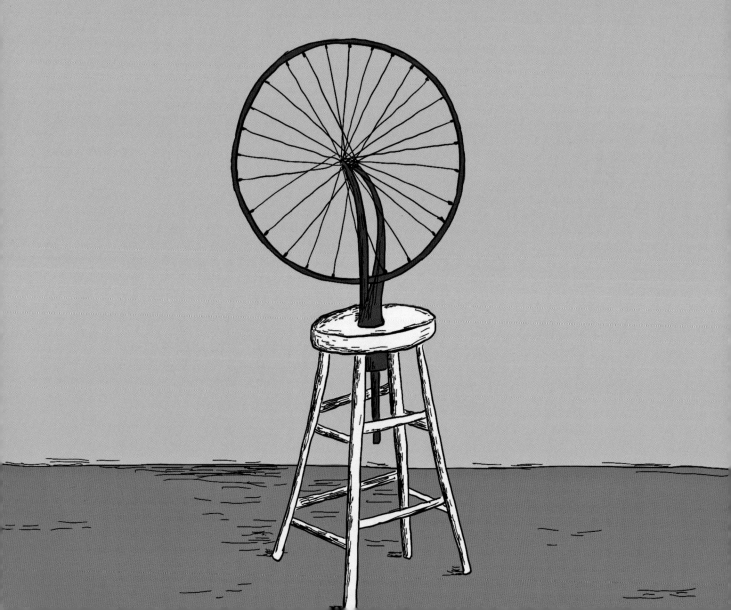

In 1917, the American Society of Independent Artists decided to hold an exhibition in New York. It would cost only six US dollars to have up to two artworks displayed.

A white object was submitted to
the exhibition council. Wait, does it
look familiar?

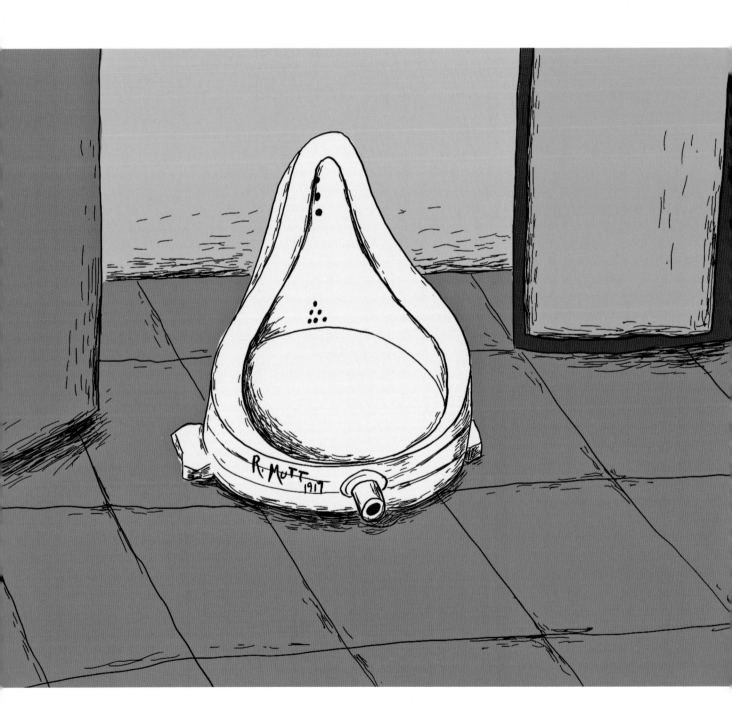

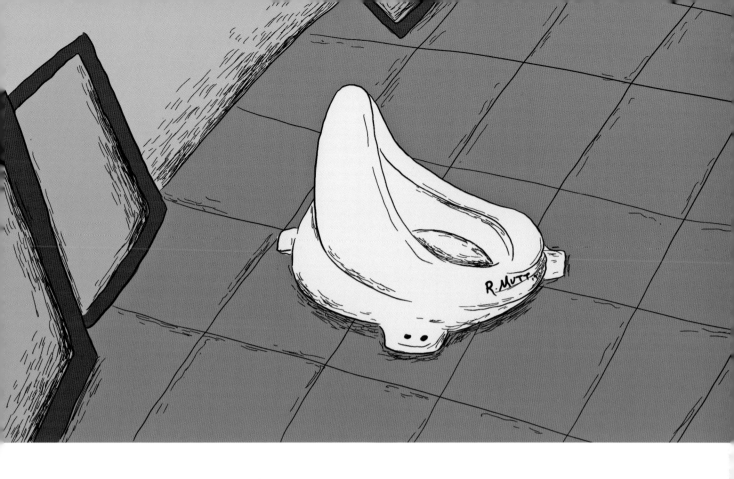

Let's turn it the other way round…
Oh, it's a urinal!

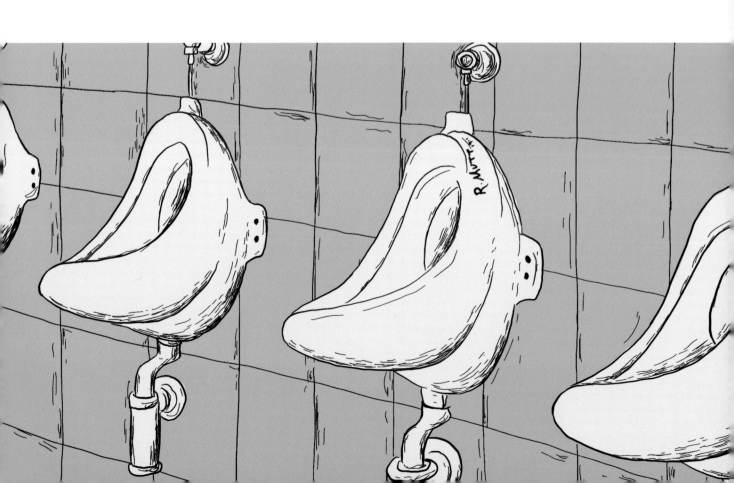

Members of the council were shocked. Was this a joke? They argued incessantly about whether the urinal, signed "R. Mutt 1917", should be considered art – and finally decided not to reject it, but not to exhibit it either.

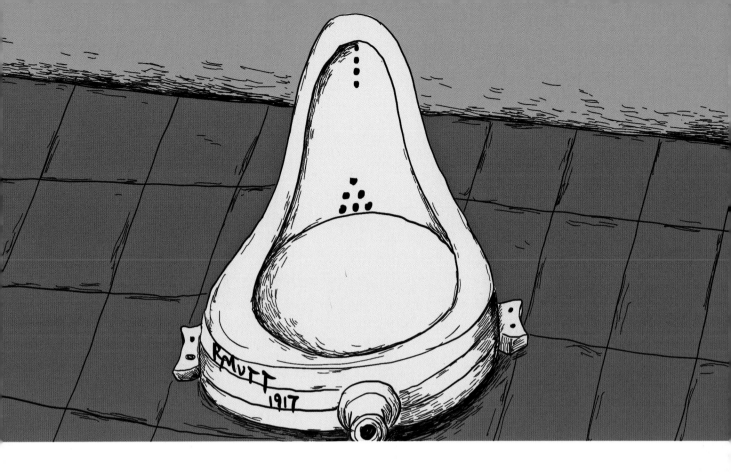

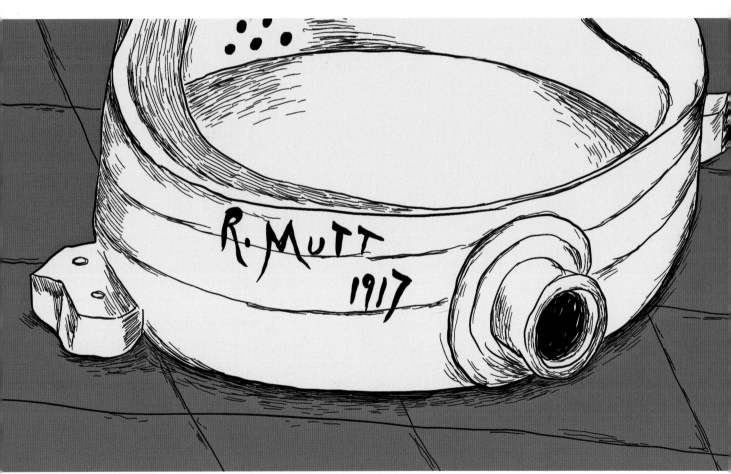

What they didn't know was that the urinal had been submitted by a member of the council – one Marcel Duchamp, who named the piece *Fountain*, and ultimately quit the council over their decision.

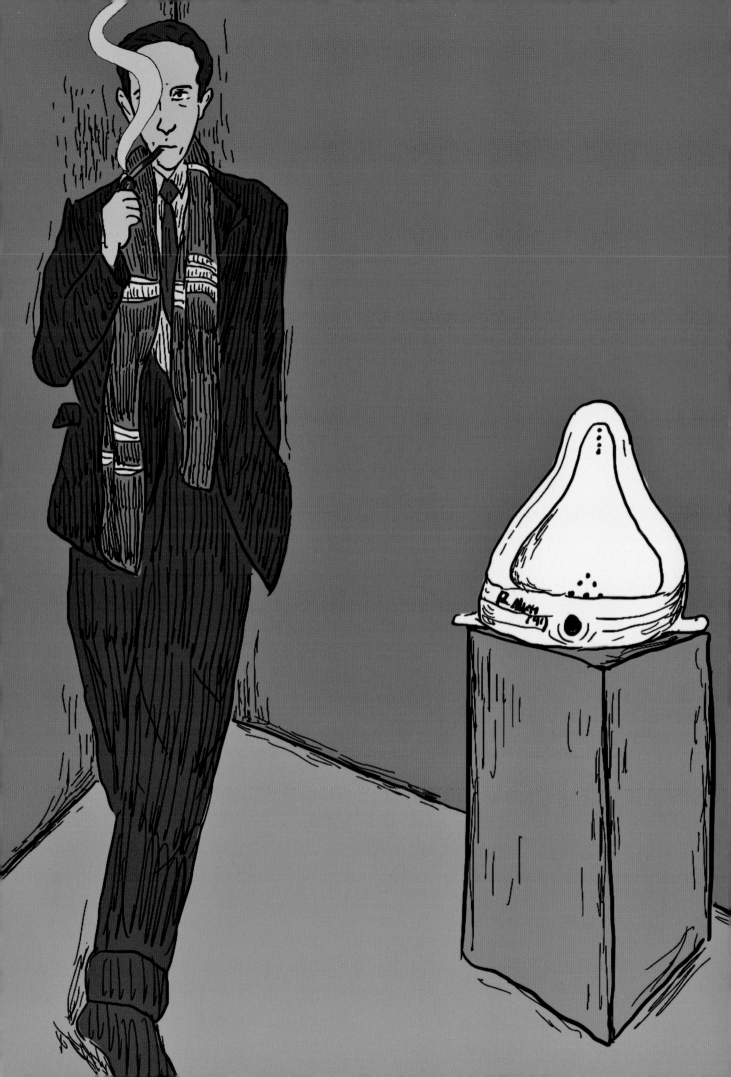

Decades later, *Fountain* became famous as a ready-made art piece, and Duchamp was recognized as one of the most influential artists of the early 20th century.

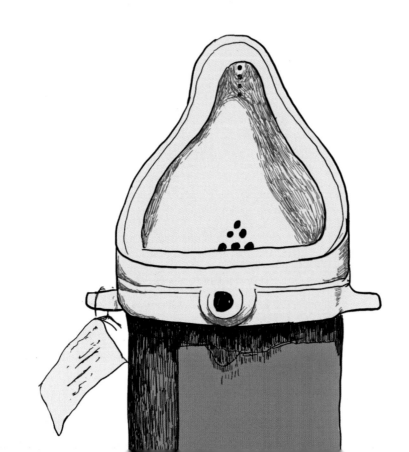

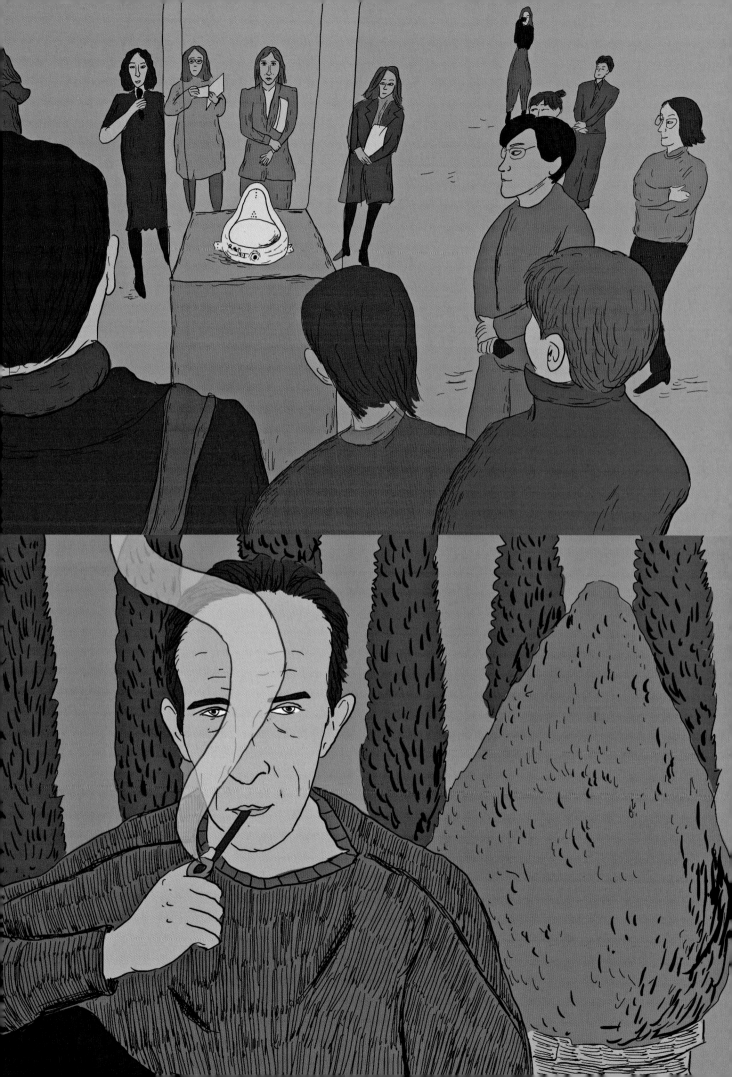

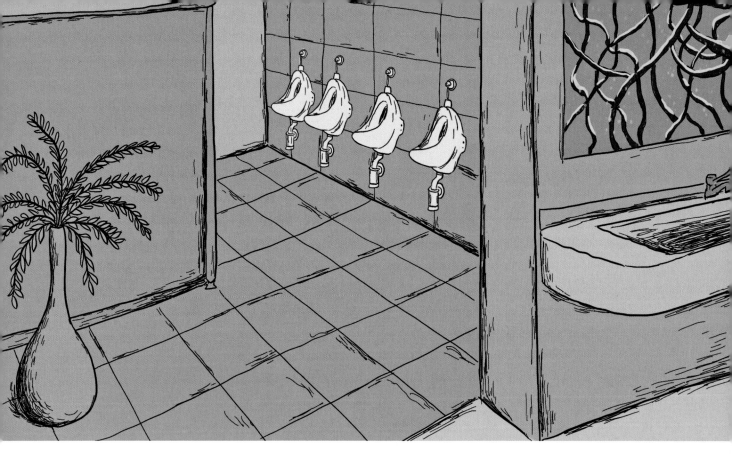

You may wonder how a ready-made object can be considered art. But what is art? This is exactly the question Duchamp wanted us to ask ourselves.

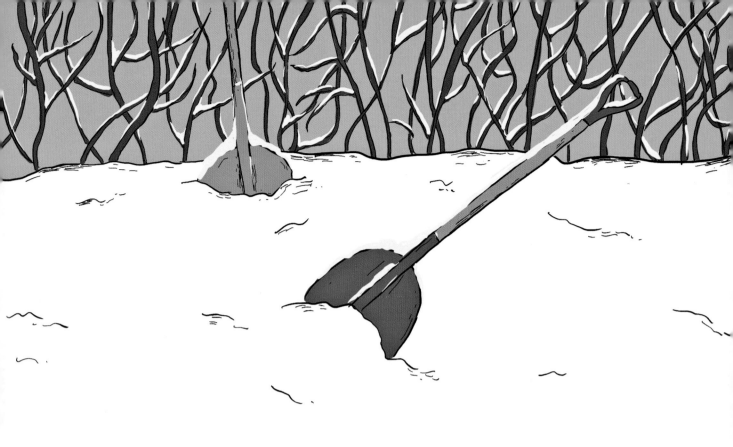

He had previously been just a normal artist.

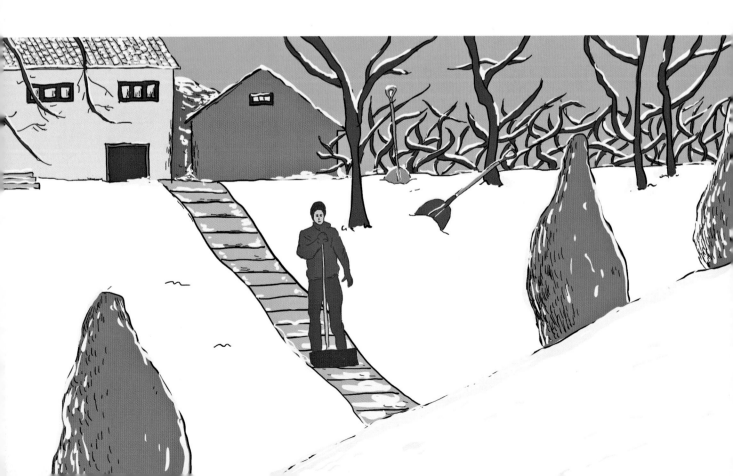

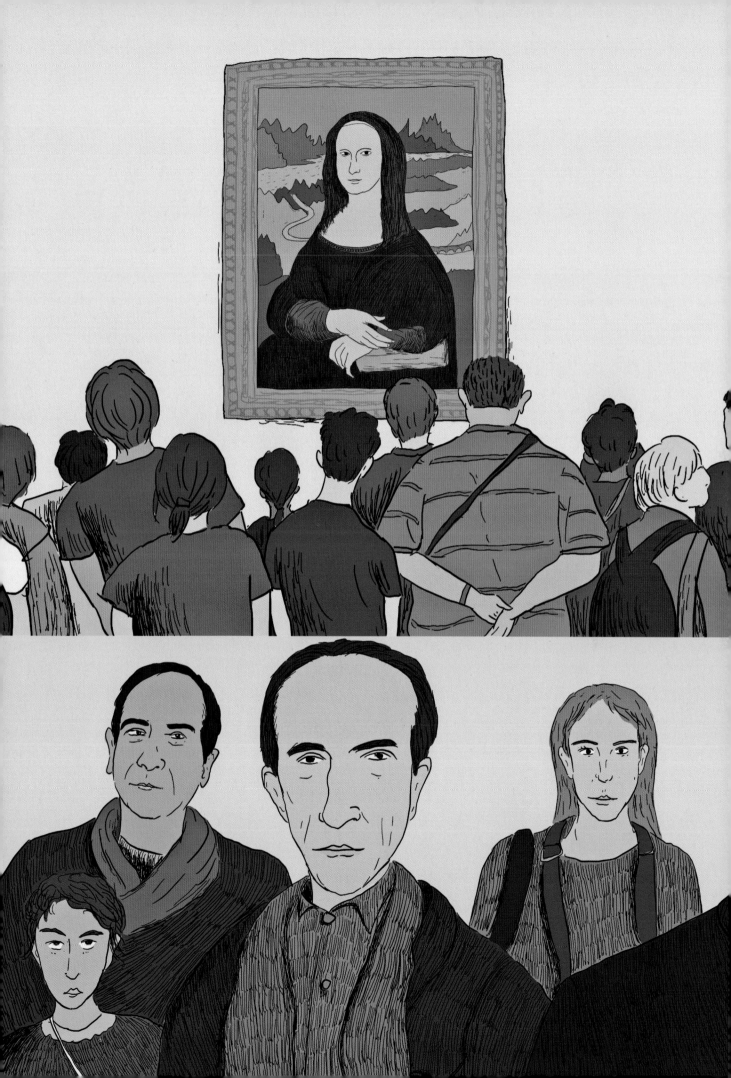

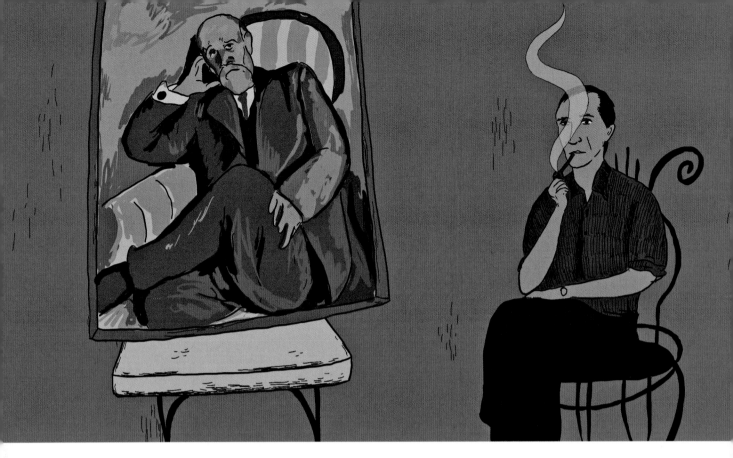

He had painted – not a lot, but when he did, he received criticism.

It made Duchamp wonder why he should listen to other people's opinions on whether his work was good enough to be called art.

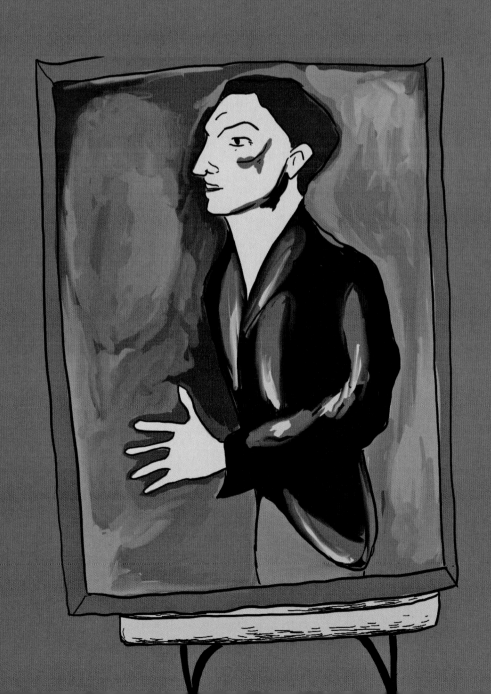

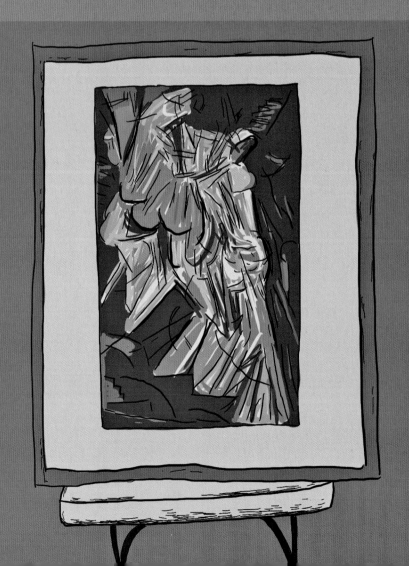

Soon he refused to paint, refused
to join any art groups, and turned
to seeking art in his daily life and
among everyday objects.

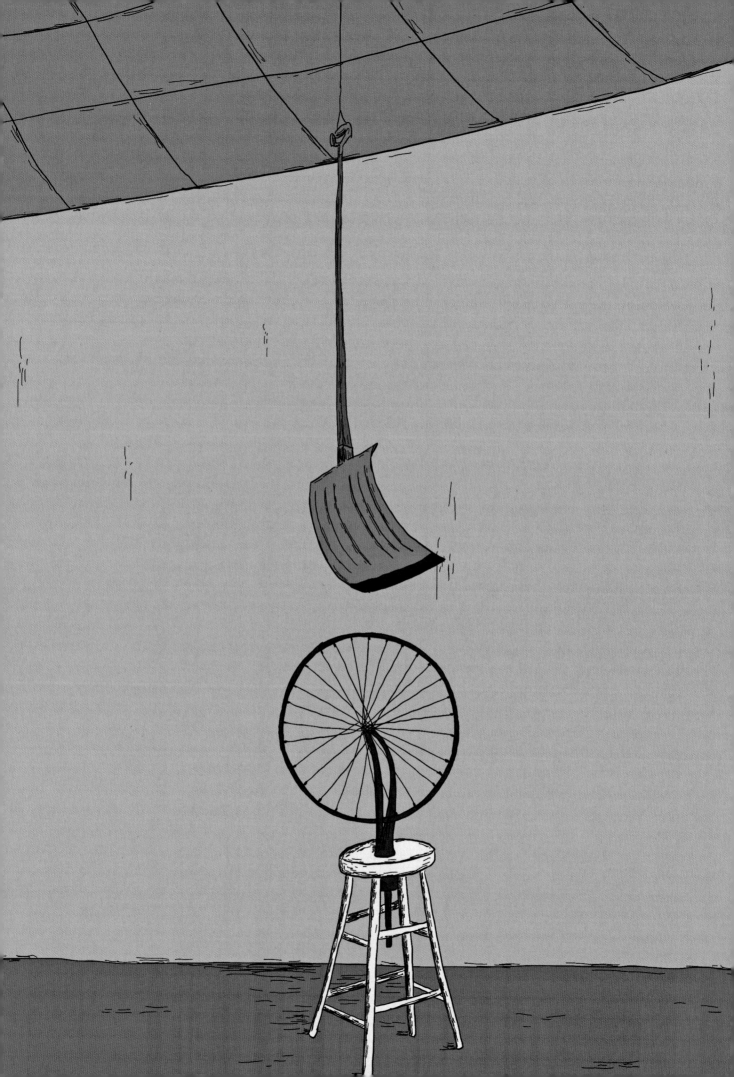

He mounted a bicycle wheel upside
down onto a stool, and called it art;
he selected a snow shovel and hung
it from the ceiling of his studio;
he drew a mustache on *Mona Lisa*;
he even spent eight years creating
two panes of glass infused with
materials such as lead foil, fuse wire
and dust; He became the king of his
own kingdom.

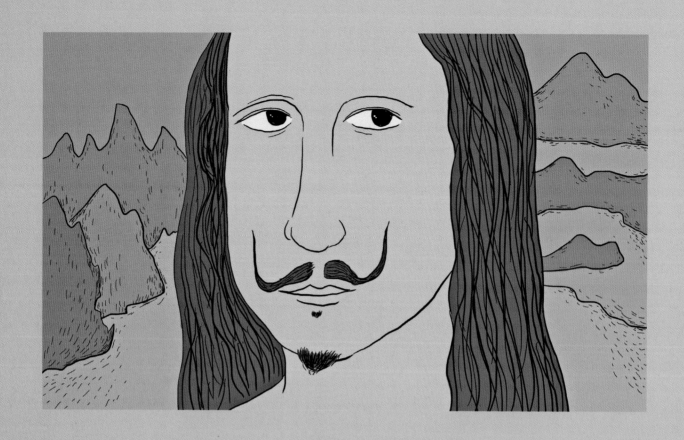

By challenging established norms, Duchamp contributed greatly to the evolution of modern art.

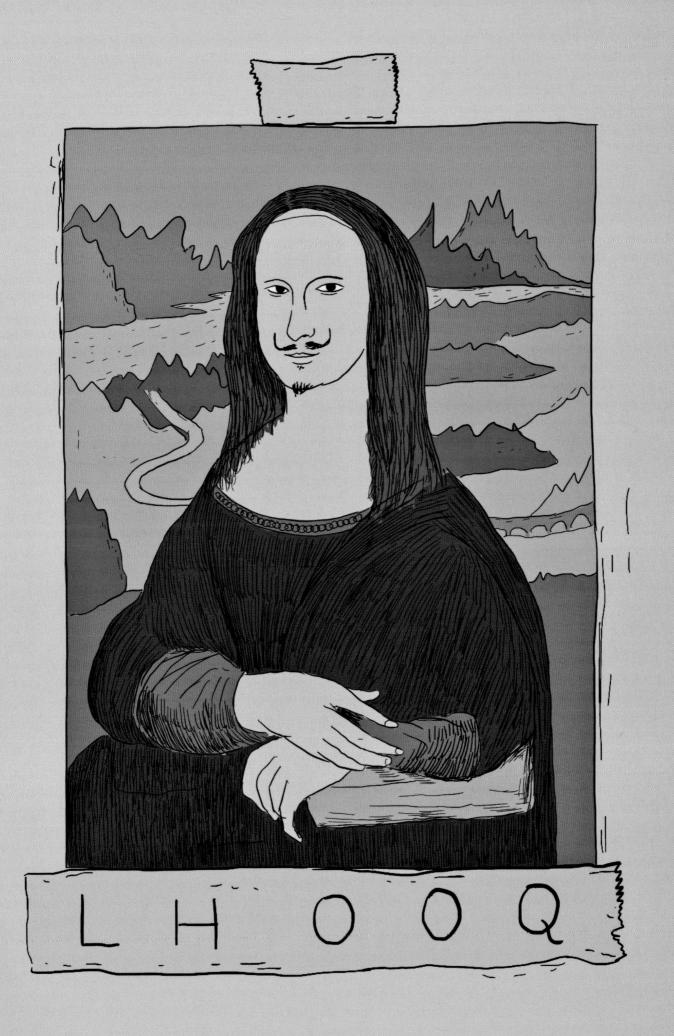

Stay free, stay curious. Maybe one day you can shake things up in the field of your choosing, like Duchamp did.

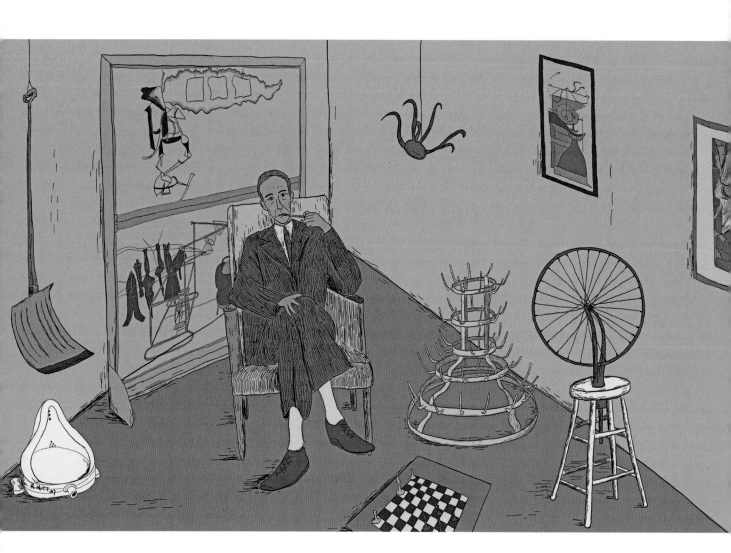

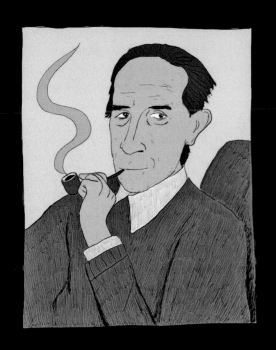

"I DON'T BELIEVE IN ART,
I BELIEVE IN THE ARTIST."

—MARCEL DUCHAMP (1887-1968)

Good night.